MW00445174

A Rhythmic Vocabulary

A Musician's Guide to Understanding and Improvising with Rhythm

by Alan Dworsky and Betsy Sansby

Illustrations by Robert Jackson
Cover Art by Marie Olofsdotter

Dancing Hands Music

"A goldmine" – DRUM Magazine

"The book is masterfully written. It's like having a good friend sitting next to you, guiding you through each lesson. It explains musical concepts in a way anyone can easily understand. The sections on cross rhythms and poly-rhythms should be required reading for any musician!"

– Professor Michael Williams, Department of Music, Winthrop University

A Rhythmic Vocabulary: A Musician's Guide to Understanding and Improvising with Rhythm

Copyright ©1997, 1999, by Alan Dworsky and Betsy Sansby

All rights reserved. No part of this book may be used or reproduced by any means without permission except the blank charts on pages 201 and 202.

Published by
Dancing Hands Music
4275 Churchill Circle
Minnetonka, MN, 55345
phone or fax: 612-933-0781
www.dancinghands.com

Book design by MacLean and Tuminelly
Cover production by Kelly Doudna
Interior design and production by Chris Long, who was tireless in his
devotion to this project

Illustrations on pages 14 and 15 by Jay Kendell

Printed in the United States of America
with soy ink on recycled, acid-free paper by Banta ISG (Viking Press)

Library of Congress Catalog Card Number: 97-091788

ISBN 0-9638801-2-8

**For Jerry Sansby,
the first drummer in the family**

We would like to express our gratitude to all our teachers, especially Marc Anderson, who generously shared his knowledge of Ghanaian rhythms with love and reverence for the culture that created them. We'd also like to thank those who have taught us through their books and videos, especially David Locke (for his clear presentation and analysis of Ghanaian rhythms), Phil Maturano (for his organization of patterns and his concept of "relayed time shifting," which we adapted into our lesson on bending a pattern), Reinhard Flatischler (whose Ta Ke Ti Na® method we adapted into rhythm walking), and Gordy Knudtson (from whom we learned – both in his books and in private lessons – a wide variety of cross-rhythms and other patterns, as well as the method we call "say-it-and-play-it"). We are also indebted to the creators of all the other sources listed at the back of this book and to all the unknown creators of the rhythms of the world.

Finally, we would like to thank Mamady Keita, who has taught us through his recordings, and whose brilliant djembe playing has been an unending source of inspiration and delight.

Who this book is for and how it works

This book is a roadmap to rhythm for any musician. It's for guitar players intrigued by the rhythms of world music. It's for keyboard players who've studied scales and chords and now want to study rhythm in a systematic way. It's for drummers, bass players, and sax players who want to groove and solo with a deeper understanding of rhythmic structure. Whatever your instrument, if you want to play funkier and don't mind using your head to do it, this book is for you.

The patterns in this book come from African and Afro-Cuban rhythms, the source for the groove in most contemporary music. But our purpose here is not to teach any specific style of drumming. Our purpose is to illuminate the subject of rhythm in general so you'll be able to navigate comfortably in any rhythmic territory.

To do that, we've organized representative patterns according to their structure, arranged them roughly in order of difficulty, and presented them in bite-sized lessons. While we present the patterns, we also present rhythmic concepts and techniques you can use to create patterns of your own. And we include plenty of examples of how patterns can be varied and combined when you improvise or solo.

We've tried to make this book as user-friendly as possible. For example, we use big, easy-to-read charts that are so simple even non-musicians can understand them. Any time we introduce a new concept or technique, we highlight it in the margin for easy reference. Any time we introduce a new term, we put it in bold letters, define it on the spot, and add it to the glossary at the back of the book. We've also included some blank charts you can photocopy and use to write down patterns of your own. We've even used a special binding that makes the book stay open without the help of a shoe.

The CD that comes with this book helps create a realistic, three-dimensional rhythmic context for you to play in right from the start. It contains two reference rhythms you'll be playing with while you practice. Each of those rhythms is recorded for about five minutes at each of seven different speeds so you can practice at your own level. And as soon as you feel like putting your instrument aside and using your whole body to learn the patterns, check out the chapter on rhythm walking.

From time to time, we tell you that a pattern comes from a particular African or Afro-Cuban rhythm. We do this to acknowledge our sources where we know the name of a rhythm and as a reminder that the patterns in this book aren't just mathematical abstractions. But just because we say a pattern can be found in a particular rhythm, it doesn't mean the pattern can be found *only* there. Most of the patterns in this book are found in many rhythmic traditions around the world and many can be heard in rock, funk, jazz, and other contemporary styles.

We hope this book will help you express yourself better in the language of rhythm and inspire you to delve deeper into the world of African and Afro-Cuban rhythms. At the back of the book, we've included a list of sources for further study and a list of CDs of great drumming from around the world. But don't stop there. Look for opportunities to experience the real thing by going to concerts, taking lessons, or joining an ensemble. There's no substitute for the direct experience of these magnificent rhythms.

Understanding the charts and basic concepts

I n this chapter, while we explain how to read the charts we'll also be explaining the basic concepts you need to know to start working your way through this book. If any of the concepts seem confusing at first, don't worry. They'll all become clearer as you begin using them in the coming lessons.

Because we're mainly interested in teaching the fundamentals of rhythmic structure, we're going to focus on just two variables of rhythm: 1) when sounds occur, and 2) what the sounds are. To notate these two variables, we use box charts instead of standard music notation because for our purposes they're simpler and clearer.

Here's what an empty chart looks like:

1	+	2	+	3	+	4	+	1	+	2	+	3	+	4	+

Pulses and subdivisions

The main function of the top row on a chart is to show how we're counting. But we also use the count row to show the **pulse**, which is indicated by shaded boxes (1 and 3 on the chart above). By "the pulse," we mean the underlying metronomic rhythm people feel in their bodies when music is played. Like your own pulse, it's made up of a series of regularly-spaced kinesthetic events called individual **pulses**. But unlike your own pulse, the pulse of a rhythm is a culturally-influenced, subjective phenomenon.

In African and Afro-Cuban music, the pulse is sometimes played on a drum or other percussion instrument. But often the pulse is silent, and – like a heartbeat – holds everything together without ever being heard. Because the pulse is so fundamental to rhythm, we present all the patterns in this book in relation to a pulse and have you tap the pulse in your feet while you play the patterns.

The time span between pulses can be divided into smaller units called **subdivisions**. The chart above has four pulses with four subdivisions each. Each individual subdivision – or **beat** – is an eighth note, which on our charts is represented by a single box. Any set of equal subdivisions forms a **grid**. Our charts use an eighth-note grid.

Whenever there's a symbol in a box beneath the count row, make a sound on that beat on your instrument:

1	+	2	+	3	+	4	+	1	+	2	+	3	+	4	+
X			X		X				X		X				

When X is the only symbol on a chart, as in the chart above, play all the notes with the same sound, either a single note or a chord. When a chart contains both X's and O's, use one sound for X's and a second sound for O's:

1	+	2	+	3	+	4	+	1	+	2	+	3	+	4	+
X			X		X					O		O			

Four and six

We say a pattern is in **four** when it can logically be represented on a chart with four pulses divided into four subdivisions each – like the charts above. Because each subdivision is an eighth note, pulses every four subdivisions fall on beats 1 and 3. In effect we're charting in **cut-time**, where a pulse falls on every half note and there are two half notes to a measure.

We chose to chart the patterns in four in cut-time because we find eighth notes easiest to work with. We could have used a quarter-note pulse divided into four sixteenth-note subdivisions. This would have made tracking the pulses easier because they would have fallen on every numbered beat instead of on beats 1 and 3.

But everything else would have been harder. Sixteenth notes are counted "one-ee-and-uh-two-ee-and-uh," and it's awkward talking about the "uh" of one or the "ee" of three. We also find a single 16-beat measure unwieldy compared to two 8-beat measures. Tradition played a role in our decision too; Afro-Cuban rhythms in four are usually charted and counted in cut-time. And if you count in eighth notes consistently in both four and six, you'll eventually be able to cross the border between them more freely.

We say a pattern is in **six** when it can logically be represented on a chart divided into two measures of six beats each, like the chart below. Each of the 12 subdivisions is an eighth note, and every eighth note is numbered. We're charting in **6/8 time**, where there are 6 eighth notes to a measure (or 12/8, if you think of the two measures as one).

In six, we generally use four pulses with three subdivisions to a pulse. This puts the pulses on beats 1 and 4:

1	2	3	4	5	6	1	2	3	4	5	6

Timelines and cycles

Almost all rhythms are organized around a steady pulse. But African and Afro-Cuban rhythms are also organized around repeating rhythmic patterns called **timelines**. Unlike the symmetrical and often silent pulse, a timeline is an *asymmetrical* and *always audible* rhythm. All the musicians in a group use the timeline as a reference and play their parts in relation to it. That's what you'll be doing when you play the patterns in this book along with the CD.

In Afro-Cuban rhythms in four, the timeline is called the **clave** (klah-vay) and it's usually played on two cylindrical pieces of wood called claves:

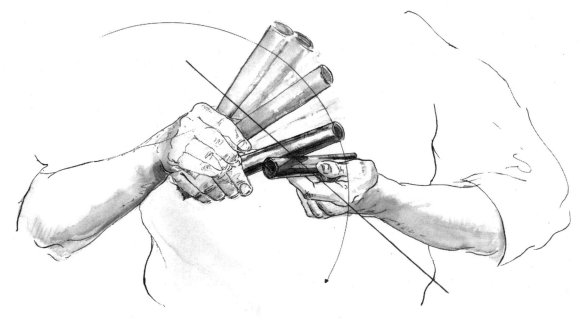

In Afro-Cuban rhythms in six and in most African rhythms, the time-line is usually played on a cowbell or other bell:

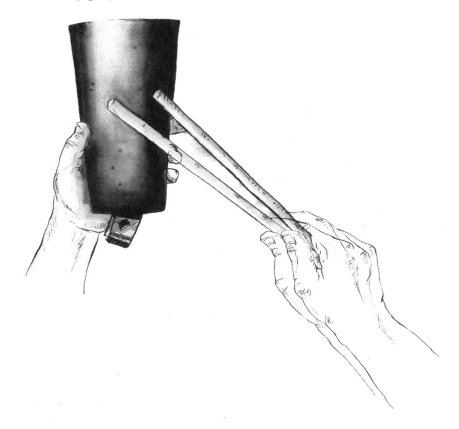

Claves and bells are ideal for timelines because they produce crisp, penetrating sounds that can be heard above other instruments.

Sometimes, to make sure you know the relationship between a pattern and a timeline, we include a chart with the timeline (instead of the pulse) indicated on the count row with shaded circles:

1	2	3	4	5	6	1	2	3	4	5	6

The number of beats from the start of one repetition of a repeating pattern to the start of the next is the pattern's **cycle**. The cycle of the timeline is typically two measures long, and whenever we use the word "cycle" without further explanation, it's this cycle we're referring to.

The cycle of the timeline repeats for as long as a rhythm is played. So think of every chart as being written in a circle. When you get to the end go right back to the beginning and start over without missing a beat. When a pattern is longer than a single row, feel free to repeat any row or any set of rows as many times as you want before moving on.

We haven't put any tempo markings on our charts. Ultimately, the tempo of a rhythm will depend on your playing situation. The important thing for now is to play each pattern at a steady tempo and not to leave a pattern until it grooves.

We've done our best to make our charts as clear as possible. But no system of written notation can capture the nuances of a live rhythm. So while you're working your way through this book, be sure to supplement your study by listening to good music. If you're unfamiliar with the percussion music of Africa and Cuba and want to hear some spectacular examples, we've listed our favorite recordings at the back of the book.

Adapting the patterns to your instrument

There's no right way to play the patterns in this book on your instrument. And since you know your instrument better than we do, we leave it up to you to find a way that works. Here are some suggestions to get you started:

Hand drums

The patterns in this book are mostly hand drum patterns, so adapting them to whatever hand drum you play should be easy. Start by playing the X's as slaps and the O's as open tones. Later you can reverse the two, add other techniques, or play on more than one drum.

Drumset

Start by playing the X's on the snare drum and the O's on a tom. Later you can reverse the two or add other voices by orchestrating the patterns around the set. While you play the patterns with your hands, you can play the pulse on your bass drum or you can alternate pulses between your bass drum and hi-hat. As you progress you can try more complicated repeating patterns in your feet. For example, you can play the pulse in one foot and a timeline in the other.

Guitar, bass, and other string instruments

Start by playing the X's as one note and the O's as another note with a lower pitch. If you play guitar, you can use chords instead of single notes. If it becomes difficult or tiresome to repeat one note or chord quickly, use two different notes for consecutive X's or O's as you would in a trill. After you're familiar with a pattern, try superimposing scales and melodies onto it.

When you're first learning a pattern, play it with a staccato touch and don't purposely sustain a sound for longer than an eighth note. After you're familiar with a pattern, experiment by sustaining notes or chords.

Piano and other keyboard instruments

Start by playing the X's as one note and the O's as another with a lower pitch, or play two different chords instead of single notes. If it becomes difficult or tiresome to repeat one note or chord quickly, use two different notes for consecutive X's or O's as you would in a trill. After you're familiar with a pattern, try superimposing scales and

melodies onto it. To create a fuller sound, try playing the patterns in your right hand over chords or a bass line in your left.

When you're first learning a pattern, play it with a staccato touch and don't purposely sustain a sound for longer than an eighth note. After you're familiar with a pattern, experiment by sustaining notes or chords.

Sax and other wind instruments

Start by playing the X's as one note and the O's as another with a lower pitch. If it becomes difficult or tiresome to repeat one sound quickly, use two different notes for consecutive X's or O's as you would in a trill. On dense patterns you can play for a cycle and then rest for a cycle or you can play continuously and insert an empty cycle whenever you need to catch your breath. After you're familiar with a pattern, try superimposing scales and melodies onto it.

When you're first learning a pattern, don't purposely sustain a note for longer than an eighth note. After you're familiar with a pattern, experiment by sustaining some of the notes.

Voice

Pick two contrasting sounds for X's and O's. Use any syllables that feel natural to you. (We like "bop" for X's and "doo" for O's.) Then try using two distinct pitches for the two sounds, with the X higher than the O. When you've mastered a pattern with just two sounds, try superimposing a melody. On dense patterns you can sing for a cycle and then rest for a cycle or you can sing continuously and insert an empty cycle whenever you need to catch your breath.

When you're first learning a pattern, don't purposely sustain a note for longer than an eighth note. After you're familiar with a pattern, experiment by sustaining some of the notes.

A method for learning any new pattern applied to the timelines on the CD

Say-it-and-play-it

You may be able to play many of the patterns in this book right off the page without any intermediate steps. But whenever you can't, you can use a simple method we call *say-it-and-play-it*. Here are the steps:

1. Count out loud
2. Tap the pulse in your feet (and keep tapping through steps 3–5)
3. Accent the pattern you're working on in your counting
4. Stop counting and vocalize the pattern
5. Play the pattern on your instrument

Once you learn this method, you can use it – or parts of it – to learn any pattern.

Now we'll walk you through all five steps while you learn the two time-lines on the CD. One is in four and the other is in six. They're among the most common timelines found in African and Afro-Cuban music, and they're among the most wonderful rhythmic patterns ever invented.

The timeline in four

Put your instrument aside for now and start counting out loud "one-and-two-and-three-and-four-and" over and over. Count as evenly as you can, with all the counts exactly the same volume and the same distance from one another. Then keep counting and start tapping the pulse in your feet on 1 and 3:

1	+	2	+	3	+	4	+	1	+	2	+	3	+	4	+
👣				👣				👣				👣			

How you tap is up to you. You can alternate feet or use just one foot. You can tap your heel or tap your toe, or you can rock back and forth from heel to toe. If you don't like moving your feet while you play, put the pulse somewhere else in your body like your hips or your head. Do whatever feels comfortable and natural to you, but keep that pulse going on 1 and 3 while you count out loud.

Now you're going to learn the timeline we use in four. This pattern is known in Afro-Cuban music as the son (sohn) clave, but it's also used in many African rhythms, where it's usually played on a bell. Whenever you're working in four and we refer to "the timeline," this is the pattern we're talking about. It's also the timeline in four you'll hear on the CD. (Later we'll introduce other timelines in four.)

We've shaded this timeline on the count row in the next chart. Keep moving your feet on the pulse and add the timeline by accenting those five notes in your counting – "ONE-and-two-AND-three-and-FOUR-and/one-and-TWO-and-THREE-and-four-and":

1	+	2	+	3	+	4	+	1	+	2	+	3	+	4	+
👣				👣				👣				👣			

Notice how each accented note of the timeline feels in relation to the pulses in your feet on 1 and 3. The first note coincides with the first pulse. The second note comes just before your foot comes down on the second pulse. The third and fourth notes fall midway between pulses. And the last note coincides with the last pulse.

Once you're able to comfortably tap the pulse in your feet on 1 and 3 while accenting the timeline in your voice, keep the pulse going but let the count drift away while you vocalize the pattern with any syllable that's comfortable for you. We like "ka" (notice we've gone back to shading the pulse on the count row):

1	+	2	+	3	+	4	+	1	+	2	+	3	+	4	+
ka				ka		ka				ka		ka			

Vocalizing is a great way to learn a new pattern because you don't have to think about technique. You can concentrate completely on rhythm. This method of learning has been used around the world for thousands of years. In Indian music, for example, there's a highly developed system for vocalizing rhythms. A student may vocalize for a year or more before being allowed to touch a drum.

In the United States, the Nigerian Babatunde Olatunji has popularized a method of vocalizing in which each syllable stands for a particular technique on the drum: "pa" is a slap with the right hand, "ta" is a slap with the left, "go" is a tone with the right hand, and so on.

Many drummers develop their own style of vocalizing to learn parts and communicate with other drummers. There's no "correct" way to vocalize rhythms; the main point is to find a way that works for you. Remember: If you can say it, you can play it.

Once you can vocalize the timeline while tapping the pulse in your feet, keep your feet going and play the pattern on your instrument. Now you know the timeline in four you'll be working with throughout this book.

The timeline in six

Next you'll use say-it-and-play-it to learn the timeline called the 6/8 bell (or the "short bell"). This timeline is widely used in African and Afro-Cuban rhythms in six, and it's usually played on a bell. Whenever you're working in six and we refer to "the timeline," this is the pattern we're talking about. It's also the timeline in six you'll hear on the CD. (Later we'll introduce other timelines in six.)

Start by counting "one-two-three-four-five-six" over and over out loud. Then keep counting and start tapping your feet on 1 and 4, the main pulse you'll be working with in six. We've shaded this pulse on the count row below:

1	2	3	4	5	6	1	2	3	4	5	6
👣			👣			👣			👣		

The timeline in six is shaded on the count row in the next chart. Keep your feet going and start accenting the pattern in your counting: "ONE-two-THREE-four-FIVE-SIX/one-TWO-three-FOUR-five-SIX":

1	2	3	4	5	6	1	2	3	4	5	6
👣			👣			👣			👣		

You may have noticed that this timeline is quite a bit harder than the timeline you learned in four. That's because most Western music is in four; six is unfamiliar territory for most of us. So slow it way down if you need to. Take your time, noticing the relationship between the notes of the pattern and each foot tap.

When you're able to comfortably tap the pulse in your feet and accent the timeline in your voice, let the count drift away and just vocalize the pattern using whatever syllable you like. When that's comfortable, keep your feet going and play the pattern on your instrument:

1	2	3	4	5	6	1	2	3	4	5	6
X		X		X	X		X		X		X

Now you know the timeline in six you'll be working with throughout this book.

Now that you've gone through all the steps of say-it-and-play-it on these two timelines, you should be able to use this method to learn any pattern. And once you're comfortable playing a pattern while tapping a pulse in your feet, you'll be ready for the joy of triple-weave practicing, which we explain in the next chapter.

CHAPTER 5
Triple-weave practicing

In African and Afro-Cuban music, rhythms are constructed of many interlocking parts played on many different instruments. The parts are woven together like voices in a fugue. You can experience something approximating this rhythmic counterpoint by using a method we call **triple-weave practicing**. This involves playing a pattern while tapping a pulse in your feet and listening to a timeline on the CD.

Triple-weave practicing teaches you to play your part in relation to what's being played around you and trains your ear to hear complex rhythmic relationships. So even if you never expect to play African or Afro-Cuban music, triple-weave practicing will help you develop skills you can apply to any musical style. And you'll be amazed at how hearing a timeline on the CD while you play brings the patterns to life.

Here are the three steps of triple-weave:

1. Turn on a timeline on the CD
2. Start tapping the pulse
3. Play a pattern on your instrument

For patterns in four use the timeline in four and for patterns in six use the timeline in six. Each timeline is recorded at seven different speeds, so you can start slow and gradually speed up.

Since you already know how to start with a pulse in your feet and then play the timelines, you shouldn't have much trouble finding the pulse by listening to the timelines on the CD. Try it now. Turn on the timeline in four at whatever speed you're comfortable with and find the pulse. Then start tapping your feet. If you need a little help locating the pulse, remember the timeline in four has two notes in it that coincide with pulses. We've put the timeline on the bottom row of the next chart so you can see again that those two notes fall on 1 in the first measure and 3 in the second:

1	+	2	+	3	+	4	+	1	+	2	+	3	+	4	+
X			X			X				X		X			

Now turn on the timeline in six, find the pulse, and get your feet going. If you need a little help locating the pulse, remember that the notes in the timeline on 1 in the first measure and 4 in the second coincide with pulses:

1	2	3	4	5	6	1	2	3	4	5	6
X		X		X	X		X		X		X

Once a timeline is playing on the CD and you're tapping the pulse in your feet, you're ready to add a pattern on your instrument.

If you just learn how to play the patterns in this book while tapping a pulse in your feet, you'll still acquire a rich rhythmic vocabulary. But you can make that vocabulary a much deeper part of you with triple-weave practicing. Once you've had a taste of it, you'll be hooked for life.

Keep in mind that you don't have to start at the triple-weave level with a new pattern. If a pattern is difficult, leave out the timeline at first and start with say-it-and-play-it, or use say-it-and-play-it *while* the timeline is playing. Whatever you do, don't rush. It's better to take your time learning just a few patterns at the triple-weave level than to run through many patterns superficially.

The pulse
and parallel figures

Playing the pulse on your instrument

In this lesson, you're not only going to tap the pulse in your feet, you're also going to play it on your instrument. Start in four. Turn on the timeline in four on the CD at medium speed. Feel the pulse on 1 and 3 and start tapping it in your feet. Then play all the pulses on your instrument:

PATTERN 1-1

1	+	2	+	3	+	4	+	1	+	2	+	3	+	4	+
X				X				X				X			

VARIATION TECHNIQUE

Create space

We're going to use these pulses to introduce the first technique for varying a pattern: *creating space*. You can create space in any pattern simply by leaving out one or more notes. Start by leaving out the second pulse in this set:

PATTERN 1-2

1	+	2	+	3	+	4	+	1	+	2	+	3	+	4	+
X								X				X			

Remember to think of every chart as being written in a circle. When you get to the end go right back to the beginning and start over without missing a beat. To really feel a pattern, you need to repeat it many times without stopping.

If you haven't tried it yet, play this pattern with the timeline at a fast speed. Notice how the absence of the second pulse changes the feel of the rhythm. Instead of flowing steadily, the pattern now leans relentlessly forward, driving to 1 in the first measure (which we'll refer to as ONE from now on). The note on ONE starts to feel like it's at the end of the pattern instead of the beginning, and the note on 1 in the second measure starts to feel like it's at the beginning of the pattern instead of in the middle.

This reconfiguration is caused by what we call *the tendency of the largest gap*, the first rhythmic concept we want to introduce. No matter where you start playing a pattern, if you repeat it enough times you'll usually come to perceive the largest gap as separating the end of the pattern from the beginning.

RHYTHMIC CONCEPT

The tendency of the largest gap

But this tendency is just that: a tendency. It's not an ironclad rule. Other factors also affect your perception of where a pattern starts, such as the tempo of the pattern, the relationship of the pattern to the start of the cycle, the relationship of the pattern to other parts being played, and the nature of the physical movements required to play the pattern.

You'll feel the tendency of the largest gap even more when you enlarge the gap by leaving out the pulse on 3 in the first measure *and* the pulse on 1 in the second. Notice that the two pulses remaining are the ones that coincide with notes in the timeline:

PATTERN 1-3

1	+	2	+	3	+	4	+	1	+	2	+	3	+	4	+
X												X			

The timeline should keep your perception of where the *cycle* starts constant even when a large gap causes you to change your perception of where a *pattern* starts.

Now you're going to play the timeline in four as a pattern on your instrument and then create space in it. Turn off the CD for now so it doesn't create the pattern for you. (In fact, whenever you work with a timeline on your instrument, we recommend that you turn off the CD.) Start by tapping the pulse in your feet and then play the full timeline pattern (notice we've switched to shading the pulse on the count row):

PATTERN 1-4

1	+	2	+	3	+	4	+	1	+	2	+	3	+	4	+
X				X				X				X			

Now take out the note on 2 in the second measure. This creates a large gap in the middle of the pattern. After a few repetitions you'll probably perceive the note on 3 in the second measure as the start of the pattern, especially if you're playing at faster speeds:

PATTERN 1-5

1	+	2	+	3	+	4	+	1	+	2	+	3	+	4	+
X				X				X				X			

Now leave off both notes in the second measure:

PATTERN 1-6

1	+	2	+	3	+	4	+	1	+	2	+	3	+	4	+
X				X											

Now switch to six, where the pulse is on 1 and 4. Turn on the timeline in six on the CD at medium speed. Feel the pulse and start tapping it in your feet. Then play all the pulses on your instrument until you really lock with the timeline. Once that starts to happen, keep going. The relationship between these two patterns can be an unending source of inspiration:

PATTERN 1-7

1	2	3	4	5	6	1	2	3	4	5	6
X			X			X			X		

Next create space by leaving out the second pulse. Notice how this makes the pattern drive to ONE just as it did in four, turning the note on 1 in the second measure into the beginning of the pattern:

PATTERN 1-8

1	2	3	4	5	6	1	2	3	4	5	6
X						X			X		

Now create more space by leaving out the pulse on 4 in the first measure *and* the pulse on 1 in the second measure. This will quickly cause the note on 4 in the second measure to feel like the beginning of the pattern (notice that these two remaining pulses are the ones that coincide with notes in the timeline):

PATTERN 1-9

1	2	3	4	5	6	1	2	3	4	5	6
X									X		

Now you're going to play the timeline in six as a pattern on your instrument and then create space in it just as you did with the timeline in four. Again, since you're going to be working with a timeline as a pattern, remember to turn off the CD. Get the pulse going in your feet and then start by playing the full timeline (notice we've switched to shading the pulse on the count row):

PATTERN 1-10

1	2	3	4	5	6	1	2	3	4	5	6
X		X		X	X		X		X		X

Now create space in the timeline by leaving off the notes on 5 in the first measure and 6 in the second (don't forget to use say-it-and-play-it and slow things way down if you need to):

PATTERN 1-11

1	2	3	4	5	6	1	2	3	4	5	6
X		X			X		X		X		

In Afro-Cuban music, this more spacious version of the timeline in six is considered to be the essence of the pattern.

You may have noticed that often the more space you put in a pattern, the more difficult it is to play. Non-musicians are impressed by lots of notes played really fast, but musicians know it can be much harder to

play fewer notes more widely spaced in time. Sometimes it's not what you play, but what you don't play, that makes the music.

lesson **2**

The pulse and the beat before

Figures are simply short rhythmic patterns. Here's a figure in four, consisting of a pulse and the beat before it:

PATTERN 2-1A

1	+	2	+	3	+	4	+	1	+	2	+	3	+	4	+
				X	X										

We call this kind of figure a **pair**, which just means two notes on consecutive beats. When you play this pair with the CD, notice that it starts on the second note of the timeline:

PATTERN 2-1B

1	+	2	+	3	+	4	+	1	+	2	+	3	+	4	+
				X	X										

Now for **parallel figures**. Two figures are parallel when:

1) they have the same structure, and

2) they have the same relationship to a pulse.

Here's an example. There are two parallel figures in the following chart – parallel pairs consisting of a pulse and the beat before it:

PATTERN 2-2

1	+	2	+	3	+	4	+	1	+	2	+	3	+	4	+
				X	X			X	X						

Even though the new figure doesn't end on the same numbered beat, it's still parallel with the first. It has the same structure (two notes on consecutive beats) and it has the same relationship to a pulse (a pulse and the beat before it). The only difference is that the new figure ends on a pulse on 1 instead of a pulse on 3.

Because these figures are short, four parallel pairs will fit in a two-measure cycle. Here's the whole set. Notice we've underlined the note on the AND of 4 in the second measure to indicate that you should start playing there:

PATTERN 2-3

1	+	2	+	3	+	4	+	1	+	2	+	3	+	4	+
X			X	X				X	X			X	X		<u>X</u>

Try to play both notes in each pair evenly, without accenting the pulse. And whenever there's a pulse sounded in a pattern, unless you've got a reason to accent it, play that note like any other. Keep tapping the pulse in your feet and feeling it in your body, but don't automatically emphasize it in your playing. Then, when you do choose to accent a note on a pulse, it will be a musical decision rather than an unconscious habit. Keep your options open. Preserve *the flexibility created by the unaccented pulse.*

RHYTHMIC CONCEPT

The flexibility created by the unaccented pulse

In the next pattern, we've created space by taking out one figure. Since the large gap this creates will cause you to perceive the note on the AND of 4 in the first measure as the start of the pattern, we have you start there:

PATTERN 2-4

1	+	2	+	3	+	4	+	1	+	2	+	3	+	4	+
X							<u>X</u>	X		X	X				X

ere's the complete set of four parallel pairs in six consisting of the pulse and the beat before in it. This is the rhythm your heart makes – "lub-dub, lub-dub, lub-dub, lub-dub":

PATTERN 2-5A

1	2	3	4	5	6	1	2	3	4	5	6
X		X	X		X	X		X	X		<u>X</u>

When you move on to triple-weave with this pattern, you may find the timeline a bit disorienting at first. Focusing on the pulse in your feet will help keep you grounded. After a while you'll be able to focus on how the pattern relates to the timeline. Then you can use the two pulses in the timeline – on 1 in the first measure and 4 in the second – as reference points. The timeline also gives you both notes of the pair that starts on 6 in the second measure:

PATTERN 2-5B

1	2	3	4	5	6	1	2	3	4	5	6
X		X	X		X	X		X	X		<u>X</u>

In the next chart, we've created some space in the pattern by taking out a figure. Now the pattern starts on 6 in the first measure:

PATTERN 2-6

1	2	3	4	5	6	1	2	3	4	5	6
X				<u>X</u>	X		X	X			X

We've taken out another figure in the next chart. Now the pattern starts on 3 in the second measure:

PATTERN 2-7

1	2	3	4	5	6	1	2	3	4	5	6
X								X̲	X		X

Before you move on, flip to page 195 and read the chapter on rhythm walking. Rhythm walking is a fun method for practicing patterns while you stretch your legs and get some fresh air. It doesn't require an instrument – which means you can do it anywhere – and it's perfect for practicing simple patterns like the ones in this lesson. The only reason we put the chapter on rhythm walking at the end of the book is that we figured you'd want to get right into the patterns. Now that you're into them, we recommend you start rhythm walking as soon as possible and make it a regular part of your practice routine.

lesson **3**

The two beats before the pulse

The pattern created by the two beats before each pulse is used a lot in African and Afro-Cuban rhythms in both four and six. In four, the notes fall on 2 and the AND of 2, and 4 and the AND of 4:

PATTERN 3-1

1	+	2	+	3	+	4	+	1	+	2	+	3	+	4	+
		X	X			X	X			X	X			X	X

This pattern looks easy, but because the figures never touch the pulse, playing them accurately can be a challenge. This is especially true at fast tempos when the space between the second note of each figure and the following pulse gets very tight.

To play this pattern right in time, it may be helpful to think of each figure as leading into the pulse that follows it: two–and–ahh, four–and–ahh, chucka–ahh, chucka–ahh. Feel each figure in your hands as connected to the pulse that follows in your foot.

Now you're going to change the pattern by using two different sounds. You can think of rhythms as songs, with each sound as a separate voice. Changing the voice of a note by changing its tone color or pitch changes the melody of a rhythm. We use the term **voicing** to refer to the sounds of the notes in a rhythmic pattern, and we call the technique of changing those sounds *changing the voicing*.

VARIATION
TECHNIQUE

Change voicing

Choose one sound for the figures starting on 2 and another sound for the figures starting on 4:

PATTERN 3-2

1	+	2	+	3	+	4	+	1	+	2	+	3	+	4	+
		O	O			X	X			O	O			X	X

The patterns in this book use either a single voice or two voices played as any two contrasting sounds. If you play a melodic instrument, this may seem like a limited palette at first. But limiting the number of sounds you use can intensify the rhythmic aspect of your playing. (If you're not convinced, listen to a djembe solo by Mamady Keita playing just slaps and open tones.) The more sounds you add, the more the ear is drawn to the melody and the more difficult it becomes to feel a rhythm's structure. So before you add more sounds, explore *the power of a limited number of voices* on your instrument.

RHYTHMIC
CONCEPT

The power of a
limited number of
voices

Now take the pattern above and reverse the two sounds on the figures. Notice how the song changes (to get the full effect, you need to play along with the timeline):

PATTERN 3-3

1	+	2	+	3	+	4	+	1	+	2	+	3	+	4	+
		X	X			O	O			X	X			O	O

Next create space by leaving off the second note in the first and third figures:

PATTERN 3-4

1	+	2	+	3	+	4	+	1	+	2	+	3	+	4	+
		X				O	O			X				O	O

When this pattern is played on a conga drum with the X's as slaps and the O's as open tones, it's the essence of the pattern commonly called "tumbao" (toom-bau) in Afro-Cuban music.

Now turn off the CD so you can practice the technique of changing voicing using the timeline as the pattern. Here are a couple variations to get you started:

PATTERN 3-5

1	+	2	+	3	+	4	+	1	+	2	+	3	+	4	+
X				O		O			X			O			

PATTERN 3-6

1	+	2	+	3	+	4	+	1	+	2	+	3	+	4	+
X				O		X				O		O			

Here's the set of parallel pairs consisting of the two beats before each pulse in six:

PATTERN 3-7A

1	2	3	4	5	6	1	2	3	4	5	6
	X	X		X	X		X	X		X	X

Use the pulse in your feet as your main reference as you play this pattern. But notice that the pattern coincides with the timeline on 5 and 6 in the first measure:

PATTERN 3-7B

1	2	3	4	5	6	1	2	3	4	5	6
	X	X		X	X		X	X		X	X

Now change the voicing. Play the second and fourth pairs with the alternate voice:

PATTERN 3-8

1	2	3	4	5	6	1	2	3	4	5	6
	X	X		O	O		X	X		O	O

Notice how the song changes when you reverse the voicing:

PATTERN 3-9

1	2	3	4	5	6	1	2	3	4	5	6
	O	O		X	X		O	O		X	X

Here's another possibility:

PATTERN 3-10

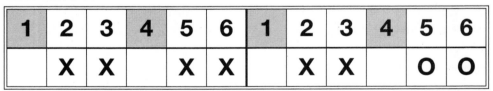

1	2	3	4	5	6	1	2	3	4	5	6
	X	X		X	X		X	X		O	O

Now use the technique of changing voicing with the timeline in six as the pattern. Turn off the CD and play these variations:

PATTERN 3-11

1	2	3	4	5	6	1	2	3	4	5	6
O		X		O	O		X		X		O

PATTERN 3-12

1	2	3	4	5	6	1	2	3	4	5	6
X		X		O	X		X		O		O

PATTERN 3-13

1	2	3	4	5	6	1	2	3	4	5	6
X		X		O	O		O		O		X

Now it's your turn. You've got three sets of parallel pairs, two time-lines, and two techniques (creating space and changing voicing) to play with. When you feel like you've gone as far as you can using just two sounds, use two different sounds on alternating cycles. Then use as many sounds as you want.

Every pattern and technique we present is intended to be a springboard for your own exploration. If you want to learn to improvise, you can't just memorize patterns. You have to practice combining the patterns and techniques in your own way. From time to time at the end of a lesson we'll remind you to do that. But even when we don't remind you, remember: You're not done with a lesson until you've played something that *isn't* on the page.

The pulse and the beat after

Here's another set of parallel pairs: the pulse and the beat after it in four. Remember to play all the notes evenly. Don't accent or emphasize the pulses:

PATTERN 4-1

1	+	2	+	3	+	4	+	1	+	2	+	3	+	4	+
X	X			X	X			X	X			X	X		

VARIATION
TECHNIQUE

Fill space

Now, instead of creating space as you did in the last lesson, you're going to *fill space*, which simply means putting in notes where there are empty beats. Start by filling space between figures by playing O's on 2 and the AND of 2 in both measures. Notice how this turns four short figures into two longer ones:

PATTERN 4-2

1	+	2	+	3	+	4	+	1	+	2	+	3	+	4	+
X	X	O	O	X	X			X	X	O	O	X	X		

Next turn off the CD and fill space in the timeline pattern:

PATTERN 4-3

1	+	2	+	3	+	4	+	1	+	2	+	3	+	4	+
X	O	O	X			X	O	O	O	X		X			

In the next chart, we've changed the voicing of the last note in the time-line and filled the space between it and the first note of the pattern. If it's difficult to repeat those four O's as a single note on your instrument, go ahead and alternate between two different notes on the O's:

PATTERN 4-4

1	+	2	+	3	+	4	+	1	+	2	+	3	+	4	+
X			X			X			X			O	O	O	O

Now play the pulse and the beat after it in six (remember to turn on the timeline in six when you're ready for triple-weave):

PATTERN 4-5

1	2	3	4	5	6	1	2	3	4	5	6
X	X		X	X		X	X		X	X	

Try the pattern with different voicing:

PATTERN 4-6

1	2	3	4	5	6	1	2	3	4	5	6
X	X		O	O		X	X		O	O	

In the next pattern, the voicing changes *within* each figure:

PATTERN 4-7

1	2	3	4	5	6	1	2	3	4	5	6
O	X		O	X		O	X		O	X	

Now vary the last pattern by filling the space on 3 in the second measure with your X sound:

PATTERN 4-8

1	2	3	4	5	6	1	2	3	4	5	6
O	X		O	X		O	X	X	O	X	

Now turn off the CD and use the technique of filling space in the timeline pattern by adding a note on 3 in the second measure:

PATTERN 4-9

1	2	3	4	5	6	1	2	3	4	5	6
X		X		X	X		X	X	X		X

Here's the same pattern with different voicing:

PATTERN 4-10

1	2	3	4	5	6	1	2	3	4	5	6
X		X		X	X		O	O	O		X

You can fill space in one spot and create space in another in the same pattern. In the next chart we've kept the note we added on 3 in the second measure and taken out the notes on 5 and 6 in the first:

PATTERN 4-11

1	2	3	4	5	6	1	2	3	4	5	6
X		X					O	O	O		X

If you haven't done it yet, pick a pattern you like and play it over and over for as long as you can. The pattern you play for a minute becomes a different pattern when you play it for an hour. Repetition triggers mysterious processes in the body and mind. That's why repetitive rhythms play a critical role in the sacred rituals of so many cultures, often inducing a state of trance in the participants. We don't talk much about *the trance effect of repetition*. We just give you the patterns and let you experience it for yourself.

RHYTHMIC
CONCEPT

The trance effect
of repetition

lesson

The two beats after the pulse

Here's the last set of parallel pairs you're going to work: the two beats after the pulse. In four, that's the AND of 1 and 2 and the AND of 3 and 4:

PATTERN 5-1A

1	+	2	+	3	+	4	+	1	+	2	+	3	+	4	+
	X	X			X	X			X	X			X	X	

Even though these pairs don't touch the pulse, the pulse is still your best reference for this pattern. It helps to feel each pair in your hands as connected to the pulse *before* it in your foot. This will keep the pairs from drifting onto the pulse and help you play them accurately even at fast speeds.

You can also use the notes where the pattern intersects with the timeline as reference points. These are 4 in the first measure and 2 in the second:

PATTERN 5-1B

1	+	2	+	3	+	4	+	1	+	2	+	3	+	4	+
	X	X			X	X			X	X			X	X	

Next we've generated two variations of this pattern by filling space in two different ways:

PATTERN 5-2

1	+	2	+	3	+	4	+	1	+	2	+	3	+	4	+
X	X	O	O	X	X			X	X	O	O	X	X		

PATTERN 5-3

1	+	2	+	3	+	4	+	1	+	2	+	3	+	4	+
X	X	O	O	X	X	O	O	X	X	O	O	X	X		

So far we've been working with patterns that are only a single cycle long. An easy way to build patterns longer than a single cycle is by *combining variations* of a pattern.

In the next chart, we've combined the two variations above to create a pattern two cycles long. Notice there's no space between the two rows under the count row. That means both rows are part of the same pattern. So after playing the first row, immediately go to the second without missing a beat. Then go back to the beginning and repeat the whole pattern:

PATTERN 5-4

1	+	2	+	3	+	4	+	1	+	2	+	3	+	4	+
X	X	O	O	X	X			X	X	O	O	X	X		
X	X	O	O	X	X	O	O	X	X	O	O	X	X		

You can use this same technique of combining variations with the timeline as the pattern. In the next chart, the first, second, and fourth cycles are one variation. The third is the full timeline with different voicing and some space filled at the end (remember to turn off the CD when you work with the timeline as a pattern):

PATTERN 5-5

1	+	2	+	3	+	4	+	1	+	2	+	3	+	4	+
X			X			X									
X			X			X									
X			X			X				O		O	O	O	O
X			X			X									

Now we'll apply the same technique of combining variations to build longer patterns in six, again using the parallel pairs of the two beats *after* the pulse. These pairs should be familiar to you because they're the same as the two beats *before* the pulse in six, which you worked with a couple lessons ago. Since there are only two beats between pulses in six, you can think of them as the two beats before, after, or *between* pulses.

Start with this two-cycle pattern created by combining two variations of the set of parallel pairs between pulses:

PATTERN 5-6

1	2	3	4	5	6	1	2	3	4	5	6
				X	X					X	X
				X	X		X	X		X	X

Next play this example of an extended improvisation based just on variations of the two beats between pulses:

PATTERN 5-7

1	2	3	4	5	6	1	2	3	4	5	6
				X	X					O	O
				X	X		X	X		O	O
				X	X					O	O
				X	X		X	X		O	O
				X	X		X	X		O	O
				X	X		X	X		O	O
				X	X		X	X		O	O
	X	X		X	X		X	X		O	O
	X	X		X	X		X	X		O	O
	X	X		X	X		X	X		O	O
	X	X		O	O		X	X		O	O
	X	X		X	X		X	X		O	O

Combining variations is a great way to get the most out of a limited vocabulary. Even musicians who know countless patterns use this technique because they understand the virtue of a fully developed idea. Use your resources wisely when you improvise. Develop one idea before moving on to the next.

lesson

Three-note figures

In this lesson, you're going to work with four sets of parallel three-note figures in four. The first is the pulse and the *two* beats before it, a common support rhythm:

PATTERN 6-1

1	+	2	+	3	+	4	+	1	+	2	+	3	+	4	+
X		X	X	X		X	X	X		X	X	X		X̲	X

When you create space in this set by leaving out the note on 3 in each measure, the pattern starts to sway a little:

PATTERN 6-2

1	+	2	+	3	+	4	+	1	+	2	+	3	+	4	+
X		X	X			X	X	X		X	X			X̲	X

Each figure in the next set of parallel three-note figures consists of the pulse and the two beats *after* it:

PATTERN 6-3

1	+	2	+	3	+	4	+	1	+	2	+	3	+	4	+
X	X	X		X	X	X		X	X	X		X	X	X	

We've varied this pattern in the next chart by leaving out the notes on 2 and changing the voicing of the notes on 4:

PATTERN 6-4

1	+	2	+	3	+	4	+	1	+	2	+	3	+	4	+
X	X			X	X	O		X	X			X	X	O	

Now play the set of parallel figures of the three beats *between* the pulses in four:

PATTERN 6-5

1	+	2	+	3	+	4	+	1	+	2	+	3	+	4	+
	X	X	X		X	X	X		X	X	X		X	X	X

Different voicings create different songs:

PATTERN 6-6

1	+	2	+	3	+	4	+	1	+	2	+	3	+	4	+
	O	O	O		O	O	O		X	X	X		X	X	X

PATTERN 6-7

1	+	2	+	3	+	4	+	1	+	2	+	3	+	4	+
	X	X	X		O	O	O		X	X	X		O	O	O

PATTERN 6-8

1	+	2	+	3	+	4	+	1	+	2	+	3	+	4	+
	X	X	X		O	O	O		O	O	O		X	X	X

In the last set of three-note figures, each figure consists of the beat before the pulse, the pulse, and the beat after:

PATTERN 6-9

1	+	2	+	3	+	4	+	1	+	2	+	3	+	4	+
X	X		X	X	X		X	X	X		X	X	X		X

With only a slight modification in the second measure, this set becomes a common palito (pah-lee-toh) pattern in the Afro-Cuban rumba (room-bah). "Palito" means "little stick" in Spanish and palito patterns are usually played with sticks on a hard surface:

PATTERN 6-10A

1	+	2	+	3	+	4	+	1	+	2	+	3	+	4	+
X	X		X	X	X		X	X		X		X	X		X

Notice how this pattern lines up with both notes of the timeline in the second measure:

PATTERN 6-10B

1	+	2	+	3	+	4	+	1	+	2	+	3	+	4	+
X	X		X	X	X		X	X		X		X	X		X

In six, there's only room for two parallel three-note figures in a two-measure cycle (if you want to keep some space between the figures). Here are two parallel three-note figures starting on 1:

PATTERN 6-11

1	2	3	4	5	6	1	2	3	4	5	6
O	O	O				O	O	O			

Now fill space in this pattern by adding a note in the alternate voice on 5 in each measure:

PATTERN 6-12

1	2	3	4	5	6	1	2	3	4	5	6
O	O	O		X		O	O	O		X	

In the next chart, we've taken this pattern and *shifted* it one beat to the left, so instead of starting on ONE, it starts on 6:

PATTERN 6-13

1	2	3	4	5	6	1	2	3	4	5	6
O	O		X		O	O	O		X		O

When a pattern is **shifted**, it stays the same but starts in a new place. Shifting has been compared to transposing a melody or chord progression to a new key, with the shifted version called a "rhythmic transposition" or "permutation" of the initial pattern. A closer analogy from tonal music is changing from one mode to another. When you change modes, you play the same scale starting on a different note; when you shift a rhythm, you play the same pattern starting on a different beat.

You can keep shifting this pattern to the left to create four more transpositions:

PATTERN 6-14

1	2	3	4	5	6	1	2	3	4	5	6
O		X		O	O	O		X		O	O

PATTERN 6-15

1	2	3	4	5	6	1	2	3	4	5	6
	X		O	O	O		X		O	O	O

PATTERN 6-16

1	2	3	4	5	6	1	2	3	4	5	6
X		O	O	O		X		O	O	O	

1	2	3	4	5	6	1	2	3	4	5	6
	O	O	O		X		O	O	O		X

Shifting allows you to turn one set of movements into many patterns. Remember: When you shift a pattern you don't need to change *how* or *what* you play, you only need to change *when* you play. Like combining variations, shifting is a great way to get the most out of a limited vocabulary.

Pathways through the grid in four

lesson

Consecutive eighth notes

In this chapter, you'll really get to know your way around the eighth-note grid in four. Start by playing every note on the grid with the same sound for a cycle and ending on ONE in the following cycle. Remember not to accent the pulse:

PATTERN 7-1

1	+	2	+	3	+	4	+	1	+	2	+	3	+	4	+
X	X	X	X	X	X	X	X	X	X	X	X	X	X	X	X
X															

Because of the relentless monotony of consecutive eighth notes played with the same sound, they work best as background percussion parts or in short, prominent bursts to signal a transition or drive the groove. During hot afternoon dance classes our drum teacher used to recharge the dancers by cracking out every eighth note with sticks on a hollow woodblock.

Usually when you play a flow of consecutive eighth notes, you won't be playing them all the same. You'll be using accents and voicing to make different patterns emerge. An **accent** is a feature of a sound that makes it stand out from its surroundings. When you give a sound a **dynamic accent**, you make it stand out by how loud or soft you play it.

VARIATION
TECHNIQUE

Add dynamic accents

In the next pattern, we *add dynamic accents* on the notes of the time-line. The large X's indicate that those notes are to be played louder than the small x's:

PATTERN 7-2

1	+	2	+	3	+	4	+	1	+	2	+	3	+	4	+
X	x	x	X	x	x	X	x	x	x	X	x	X	x	x	x

You can also make a pattern emerge using voicing. In the next pattern, we make the timeline emerge from a continuous flow of eighth notes by playing it in the alternate voice:

PATTERN 7-3

1	+	2	+	3	+	4	+	1	+	2	+	3	+	4	+
O	X	X	O	X	X	O	X	X	X	O	X	O	X	X	X

We use voicing to make a different pattern emerge from a continuous flow of eighth notes in the next chart:

PATTERN 7-4

1	+	2	+	3	+	4	+	1	+	2	+	3	+	4	+
X	X	O	O	O	O	O	O	X	X	O	O	O	O	O	O

Now cut the pattern off after beat 3 in the second measure to create some space between cycles:

PATTERN 7-5

1	+	2	+	3	+	4	+	1	+	2	+	3	+	4	+
X	X	O	O	O	O	O	O	X	X	O	O	O			

Shifting this pattern to start on 3 in the second measure gives us a drum part from the Ghanaian rhythm panlogo (pahn-loh-goh):

PATTERN 7-6

1	+	2	+	3	+	4	+	1	+	2	+	3	+	4	+
O	O	O	O	X	X	O	O	O			<u>X</u>	X	O	O	

When a pattern starts in one cycle and ends after the first beat in the next cycle, it makes a rhythm feel more circular, without a clear beginning or end. *The circular effect of overlapping ONE can reconfigure how you hear the timeline and other patterns in a rhythm.*

RHYTHMIC CONCEPT

The circular effect of overlapping ONE

In the next pattern, the short figures overlap 1 in both measures:

PATTERN 7-7

1	+	2	+	3	+	4	+	1	+	2	+	3	+	4	+
O	O					O	O	O	O					O	O

Here's a longer pattern created by combining variations of these figures with parallel pairs. It ends with a string of consecutive eighth notes:

PATTERN 7-8

1	+	2	+	3	+	4	+	1	+	2	+	3	+	4	+
														O	O
O	O													O	O
O	O													O	O
O	O					O	O	O	O					O	O
O	O													O	O
O	O			X	X			O	O			X	X	O	O
O	O			X	X			O	O			X	X	O	O
O	O	O	O	X	X	O	O	O	O	O	O	X	X	O	O
O	O														

The change in perspective created by overlapping ONE can either be trance-inducing or confusing, depending on how easy it is for you to hold on to your part. When we first started playing patterns that overlapped the start of the cycle, we were constantly looking at each other and whispering "Where's ONE?" But now that you understand the overlap effect, you can skip confusion and go straight to trance.

Numbered beats and upbeats

Here's the set of numbered beats in four:

PATTERN 8-1

1	+	2	+	3	+	4	+	1	+	2	+	3	+	4	+
X		X		X		X		X		X		X		X	

This set is made up of pulses on 1 and 3 and **upbeats** on 2 and 4. We define an upbeat as a beat falling midway between two pulses. Notice that there are two upbeats in the timeline:

PATTERN 8-2

1	+	2	+	3	+	4	+	1	+	2	+	3	+	4	+
	X					X				X				X	

Because upbeats are defined in relation to the pulse, if the pulse changes, the upbeats will change. For example, if you're working with a rhythm in four that only requires two subdivisions to a pulse, you could put a pulse on every numbered beat. Then the ANDs would become the upbeats because they would fall midway between each two pulses:

1	+	2	+	3	+	4	+	1	+	2	+	3	+	4	+
	X		X		X		X		X		X		X		X

In six – with pulses on 1 and 4 – there are no upbeats on our charts because there is no beat midway between the pulses on the eighth-note grid:

1	2	3	4	5	6	1	2	3	4	5	6

Now go back to the set of upbeats in four with the pulse on 1 and 3 and create space by leaving out the first upbeat:

PATTERN 8-3

1	+	2	+	3	+	4	+	1	+	2	+	3	+	4	+
							X				X				X

By leaving out the upbeat on 2 in the second measure instead, you can create a pattern that overlaps ONE:

PATTERN 8-4

1	+	2	+	3	+	4	+	1	+	2	+	3	+	4	+
			X				X								<u>X</u>

Next we're going to work with a pattern made up of three numbered beats – two pulses and an upbeat:

PATTERN 8-5A

1	+	2	+	3	+	4	+	1	+	2	+	3	+	4	+
X				X		O		X				X		O	

This pattern is common in African and Afro-Cuban music, and can probably be heard almost everywhere else in the world. It's simple, but it grooves hard.

When you play this pattern slowly, the tendency is to hear it as two parallel figures that start on 1:

PATTERN 8-5B

1	+	2	+	3	+	4	+	1	+	2	+	3	+	4	+
X				X		O		X				X		O	

Figure 1 Figure 2

The timeline, which starts on ONE, reinforces this way of hearing the pattern.

But when you play this pattern fast, the tendency of the largest gap takes over, causing you to hear it as two parallel figures that start on 3:

PATTERN 8-5C

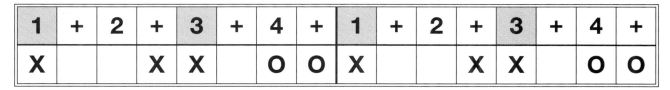

1	+	2	+	3	+	4	+	1	+	2	+	3	+	4	+
X				X̲		O		X				X		O	

Figure 1 Figure 2

Next we've filled space in this pattern to create three variations. Play each variation separately until it grooves. Then try combining variations to build a longer pattern or make up variations of your own:

PATTERN 8-6

1	+	2	+	3	+	4	+	1	+	2	+	3	+	4	+
X				X	X	O		X				X	X	O	

PATTERN 8-7

1	+	2	+	3	+	4	+	1	+	2	+	3	+	4	+
X				X	X	O	O	X				X	X	O	O

PATTERN 8-8

1	+	2	+	3	+	4	+	1	+	2	+	3	+	4	+
X				X	X	O	O	X	X			X	X	O	O

PATTERN 8-9

1	+	2	+	3	+	4	+	1	+	2	+	3	+	4	+
X			X	X		O	O	X	X	X	X	X		O	O

In the next chart we've alternated between a variation of pattern 8-7 (a djembe part from Kassa, a rhythm from Guinea) and a pattern of parallel pairs. Repeat each line as many times as you like before moving on to the next:

PATTERN 8-10

1	+	2	+	3	+	4	+	1	+	2	+	3	+	4	+
X		X	X			O	O	X			X	X		O	O
		X	X			O	O			X	X			O	O

Patterns are like words in your vocabulary. To form meaningful sentences, you need to put words together. From now on we regularly combine new patterns with ones you already know. Use these combinations as examples of how you can put your vocabulary to work.

lesson

Offbeats

Offbeats are all the beats between pulses (except upbeats). The way we're counting in four, the offbeats on the eighth-note grid are the ANDS. For now, leave out the timeline and just get a feel for how they fit with the pulse:

PATTERN 9-1A

1	+	2	+	3	+	4	+	1	+	2	+	3	+	4	+
	X		X		X		X		X		X		X		X

When you pick up the tempo and add the timeline, the numbered beats (also called **onbeats**, meaning all beats that aren't offbeats) turn into magnets that tug on the nearby offbeats. It takes concentration to resist the tug and hold the offbeats in place. If your concentration slips – even for a moment – you'll find yourself thinking "This isn't so hard!" until you realize you're playing 1-2-3-4 instead of AND-AND-AND-AND.

One way to make sure your offbeats don't slide onto the numbered beats is to add **ghost notes**, which are light, barely-audible taps on the empty beats in a pattern. In the next chart, we've *added ghost notes* (indicated by dots) on the numbered beats. Experiment to see if there's a way to tap them or play them softly on your instrument with one hand while you play the offbeats with the other:

VARIATION
TECHNIQUE

Add ghost notes

PATTERN 9-1B

1	+	2	+	3	+	4	+	1	+	2	+	3	+	4	+
•	X	•	X	•	X	•	X	•	X	•	X	•	X	•	X

Besides helping you keep your place, ghost notes can add to the groove of a pattern by providing a subtle, underlying support rhythm. But be careful how you use them when other instruments are playing. Adding ghost notes to an already-dense rhythm can make it sound cluttered. So it's best to learn how to play patterns both ways – with and without ghost notes.

Now take out the ghost notes, turn on the timeline, and alternate between playing the offbeats for a cycle and resting for a cycle. Doing these rhythmic wind sprints will build your endurance so you'll eventually be able to resist the tug of the numbered beats for an extended stretch. Notice that the single offbeat in the timeline (on the AND of 2 in the first measure) gives you a reference point:

PATTERN 9-1C

1	+	2	+	3	+	4	+	1	+	2	+	3	+	4	+
	X		X		X		X		X		X		X		X
X															

Because straight offbeats generate so much rhythmic tension, you'll rarely be called upon to play more than a cycle's worth in an actual playing situation. So if you can make it through even one cycle of offbeats you're in great shape.

Here are a couple common patterns that combine sequences of offbeats and numbered beats. To emphasize the structure of the patterns, we use O's for the offbeats and X's for the numbered beats. And because each pattern generates some tension with the timeline at different points, we've shaded the timeline on the count row:

PATTERN 9-2

1	+	2	+	3	+	4	+	1	+	2	+	3	+	4	+
X		X		X		X		X			O		O		

PATTERN 9-3

1	+	2	+	3	+	4	+	1	+	2	+	3	+	4	+
X		X			O		O		O			X		X	

The next pattern, which is played on the high conga drum in the Afro-Cuban rumba, has notes on three of the four offbeats in each measure. Use the note on 2 in each measure to steady yourself before diving back into the offbeats that start on the AND of 3. You can also use ghost notes if you want. We've kept the timeline on the count row so you can use it as a reference:

PATTERN 9-4

1	+	2	+	3	+	4	+	1	+	2	+	3	+	4	+
	X	X			O		O		X	X			O		O

You probably noticed that the tendency of the largest gap reconfigured the pattern into two figures that overlapped the bar lines and obscured ONE. By creating space in the pattern, you can keep it starting on the AND of 1 in the first measure:

PATTERN 9-5

1	+	2	+	3	+	4	+	1	+	2	+	3	+	4	+
	X	X				O		O		X	X				

By filling space in the original pattern you can throw a blanket over each bar line:

PATTERN 9-6

1	+	2	+	3	+	4	+	1	+	2	+	3	+	4	+
O	X̲	X			O	O	O	O	X	X			O	O	O

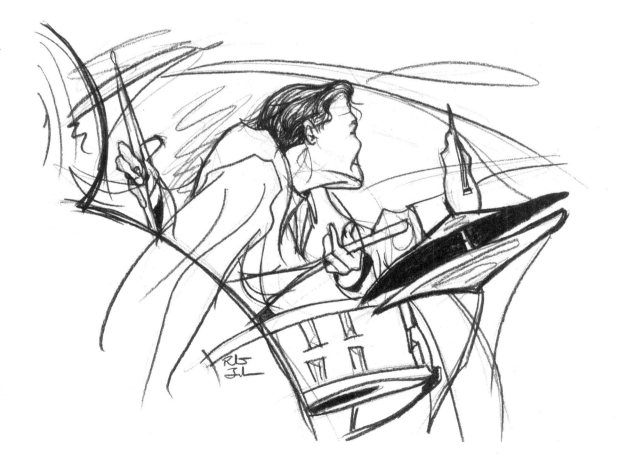

In this last chart, we've built a longer pattern by combining variations of this pattern with a couple other patterns:

PATTERN 9-7

1	+	2	+	3	+	4	+	1	+	2	+	3	+	4	+
	X	X			O		O	X	X						
	X	X			O		O	X	X						
	X	X			O		O	X	X				O		O
	X	X			O		O	X	X						
	X	X		O	O	O	O	X	X						
	X	X		O	O	O	O	X	X						
	X	X		O	O	O	O	X	X				O	O	O
O	X	X		O	O	O	O	X		X		X		X	
	X		X	O	O	O	O	X	X						

VARIATION
TECHNIQUE

Adjust the volume

After you're comfortable playing this pattern, go back and vary it by *adjusting the volume.* First play the whole pattern loud. Then play it soft. Notice how adjusting the volume affects the character of the pattern. Then play it again, letting the volume rise and fall as if you were speaking. Sometimes shouting is the best way to get your point across; sometimes whispering works better.

lesson 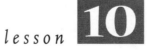 **10**

Singles and pairs

Playing singles and pairs is an easy way to create a variety of patterns without having to think too much. Just play any combination of single notes and pairs and follow each single or pair with one empty beat. To create a pattern in four that repeats every two

measures there's just one more thing to remember: use an even number of pairs.

Here's a singles-and-pairs pattern with two pairs that starts on ONE:

PATTERN 10-1

1	+	2	+	3	+	4	+	1	+	2	+	3	+	4	+
X		X		X	X		X		X		X	X		X	

Notice what happens when you switch from a single to a pair in four. If the last single you played was on a numbered beat – like the single on 2 in the first measure above – a pair will switch you to the AND-track. That's what the pair starting on 3 in the first measure does. If the last single you played was on an offbeat – like the single on the AND of 1 in the second measure above – a pair will switch you to the numbered beats. That's what the pair starting on the AND of 2 in the second measure does.

Here's a singles and pairs pattern known in Afro-Cuban music as a mambo bell pattern:

PATTERN 10-2

1	+	2	+	3	+	4	+	1	+	2	+	3	+	4	+
X		X	X		X		X	X		X		X		X	

Here's a second mambo bell pattern, also known as a cascara pattern. "Cascara" means shell, and this pattern is often played with sticks on the shell of a timbale. Notice that it has four pairs (including the pair that overlaps ONE):

PATTERN 10-3

1	+	2	+	3	+	4	+	1	+	2	+	3	+	4	+
X		X	X		X		X	X		X		X	X		X

Here's a third mambo bell pattern. Notice that this one has no note on ONE:

PATTERN 10-4

1	+	2	+	3	+	4	+	1	+	2	+	3	+	4	+
	X		X		X		X	X		X		X	X		X

The next pattern doesn't have a note on 1 in either measure. It's a bell part in the Puerto Rican rhythm called bomba (bohm-bah). Notice that two pairs surround each pulse on 1 while the singles fall on each pulse on 3:

PATTERN 10-5

1	+	2	+	3	+	4	+	1	+	2	+	3	+	4	+
	X	X		X		X	X		X	X		X		X	X

Here's an Afro-Cuban bell pattern with two voices. Notice that it starts on 1 in the second measure:

PATTERN 10-6

1	+	2	+	3	+	4	+	1	+	2	+	3	+	4	+
O	O			X		X		O		O		X	X		O

In each of the following patterns there's a pair starting on 3 in the first measure. In the first pattern, that pair is followed immediately by a second pair. Then in each succeeding pattern, the appearance of the second pair is postponed longer and longer. This makes the string of offbeat singles following the first pair longer and longer. The offbeat singles create tension, and the tension builds until the pattern is returned to a numbered beat by the second pair:

PATTERN 10-7

1	+	2	+	3	+	4	+	1	+	2	+	3	+	4	+
X		X		O	O		X	X		X		O		O	

PATTERN 10-8

1	+	2	+	3	+	4	+	1	+	2	+	3	+	4	+
X		X		O	O		X		X	X		O		O	

PATTERN 10-9

1	+	2	+	3	+	4	+	1	+	2	+	3	+	4	+
X		X		O	O		X		X		O	O		O	

PATTERN 10-10

1	+	2	+	3	+	4	+	1	+	2	+	3	+	4	+
X		X		O	O		X		X		O		O	O	

PATTERN 10-11

1	+	2	+	3	+	4	+	1	+	2	+	3	+	4	+
X		X		O	O		X		X		O		O		O

These patterns work well with just about any dance music in four, so pull out your favorite CD now and try playing along. Besides being a fun way to practice, playing with recorded music is a great way to develop your overall musicianship because it requires you to listen to many other parts while holding your own. And especially when you're a beginner, playing with recorded music may be the only way you can experience what it's like to play with a band. Our CD player has allowed us to play with Sting, Steely Dan, Los Munequitos, and Youssou N'Dour – and not one of them has complained about our playing.

lesson

Backbeats

In lesson 2, we recommended that for the sake of flexibility you avoid the habit of automatically accenting the pulse in every pattern. In this lesson, you're going to intentionally accent the pulses called **backbeats**, which we define as every second pulse. In four, with the pulse on 1 and 3, the backbeats fall on beat 3 in each measure:

PATTERN 11-1A

1	+	2	+	3	+	4	+	1	+	2	+	3	+	4	+
				X								X			

When you count in sixteenth notes, the backbeats fall on 2 and 4:

PATTERN 11-1B

1	e	+	a	2	e	+	a	3	e	+	a	4	e	+	a
				X								X			

There's something about the backbeat that makes a body want to move. That's why you'll find a solid backbeat at the heart of most popular dance music. Drummers usually emphasize the backbeat by playing it with a loud rim shot on the snare drum. This high cracking sound is usually balanced by a contrasting low thud on the bass drum on 1.

Whatever instrument you play, for this lesson imagine it's a drumset and play your version of a bass drum on 1 and your version of a snare drum on 3:

PATTERN 11-2

1	+	2	+	3	+	4	+	1	+	2	+	3	+	4	+
O				X				O				X			

Now create some space in this pattern by leaving out the note on 1 in the second measure:

PATTERN 11-3

1	+	2	+	3	+	4	+	1	+	2	+	3	+	4	+
O				X								X			

Now you're going to keep these three notes constant while playing a series of variations on them. Start by adding a bass drum note on 2 in the second measure:

PATTERN 11-4

1	+	2	+	3	+	4	+	1	+	2	+	3	+	4	+
O				X						O		X			

Now add another bass drum note on 2 in the first measure:

PATTERN 11-5

1	+	2	+	3	+	4	+	1	+	2	+	3	+	4	+
O		O		X						O		X			

Next try some variations that add offbeats:

PATTERN 11-6

1	+	2	+	3	+	4	+	1	+	2	+	3	+	4	+
O		O		X			O	O	O			X		O	

PATTERN 11-7

1	+	2	+	3	+	4	+	1	+	2	+	3	+	4	+
O			O	X						O		X	O		

1	+	2	+	3	+	4	+	1	+	2	+	3	+	4	+
O		O		X	O	O		O		O	O	X			

The next variation has a series of five consecutive offbeats in the O voice starting on the AND of 2 in the first measure:

PATTERN 11-9

1	+	2	+	3	+	4	+	1	+	2	+	3	+	4	+
O			O	X	O		O		O		O	X			O

Now go back to the original pulse-backbeat pattern and add a note after each backbeat to create two parallel figures:

PATTERN 11-10

1	+	2	+	3	+	4	+	1	+	2	+	3	+	4	+
O				X	X			O				X	X		

An interesting way to vary parallel figures is to *displace one note* in one of the figures by a single beat. In the next pattern, we've displaced the note on 3 in the second figure and moved it to the preceding beat. Now the two X's in the second measure surround the pulse on 3 without touching it:

PATTERN 11-11

1	+	2	+	3	+	4	+	1	+	2	+	3	+	4	+
O				X	X			O				X		X	

As you work your way through the patterns in this book, in addition to practicing them with a timeline, it's also good to practice them with a metronome. In some ways this is harder because the metronome doesn't define any of the subdivisions of the pulse for you and forces you to keep track of the cycle yourself. The relentless click of the metronome – like the timeline on the CD – will also help you develop steady time, the most fundamental aspect of rhythm. Without steady time, even the fanciest rhythmic vocabulary will sound like irritating chatter.

lesson

Sixteenth notes

Even when the pulse is moving at a moderate speed, sixteenth notes move very fast. (If you've been counting in sixteenth notes all along, then our sixteenth notes are thirty-second notes for you.) It's hard to play *discontinuous* patterns accurately at that speed and hard for the ear to discern such intricate rhythms. So we'll be using sixteenth notes to embellish or thicken the texture of patterns in which the basic unit of time remains the eighth note. If you want to explore the sixteenth-note grid more thoroughly on your own, just take any eighth-note pattern in the book and play it twice as fast while keeping the speed of the pulse and the timeline unchanged.

We chart sixteenth notes as two notes within a single eighth-note box. In the next chart, there are two sixteenth notes in the box under beat 1 in the second measure:

PATTERN 12-1

1	+	2	+	3	+	4	+	1	+	2	+	3	+	4	+
X	O	O	O	O				xx	O	O	O	O			

As you play this pattern, when you switch from sixteenth notes to eighth notes on the AND of 1 in the second measure, *don't slow down gradually*. The four O's in the second measure should sound just like the four in the first.

You can *substitute sixteenth notes* for any eighth note. In the next pattern, we've substituted sixteenth notes for the first two eighth notes in the second figure. If it's awkward on your instrument to repeat a single sound quickly four times in a row, use more than one sound on the sixteenth notes:

PATTERN 12-2

1	+	2	+	3	+	4	+	1	+	2	+	3	+	4	+
X	X	O	O	O				xx	xx	O	O	O			

In the next pattern, we've substituted sixteenth notes for the first four eighth notes in the second figure. This time you'll switch voices while playing sixteenth notes. Again, make sure the last three notes in the second measure sound just like the last three notes in the first:

PATTERN 12-3

1	+	2	+	3	+	4	+	1	+	2	+	3	+	4	+
X	X	O	O	O	O	O		xx	xx	oo	oo	O	O	O	

When you insert sixteenth notes *between* eighth notes, you have to switch speeds cleanly going in *and* coming out. In the next pattern, we take the set of parallel pairs consisting of the pulse and the beat after and fill the space between the last and first figures with sixteenth notes:

PATTERN 12-4

1	+	2	+	3	+	4	+	1	+	2	+	3	+	4	+
X	X			X	X			X	X			X	X	oo	oo

Next you're going to work with a figure consisting of consecutive eighth notes. Notice that it starts right after the third note in the timeline:

PATTERN 12-5

1	+	2	+	3	+	4	+	1	+	2	+	3	+	4	+
						O	O	O	O	O	X	X			

When you substitute two sixteenth notes for the first eighth note in the figure, it becomes a pattern played on the high drum in the Afro-Cuban rumba:

PATTERN 12-6

1	+	2	+	3	+	4	+	1	+	2	+	3	+	4	+
						oo	O	O	O	O	X	X			

Now build a longer pattern by repeating the figure and then adding a parallel figure:

PATTERN 12-7

1	+	2	+	3	+	4	+	1	+	2	+	3	+	4	+
						oo	O	O	O	O	X	X			
						oo	O	O	O	O	X	X			
						oo	O	O	O	O	X	X			oo
O	O	O	O	X	X	oo	O	O	O	O	X	X			

Here's an exercise that can help you develop greater speed and accuracy on your sixteenth notes. Pick any pattern you want to work on that has just one voice. Then play the notes of the pattern with eighth notes and fill all the spaces in between with sixteenth

notes in the alternate voice (or two alternate voices if you need to). For example, here's how the timeline would be played:

PATTERN 12-8

1	+	2	+	3	+	4	+	1	+	2	+	3	+	4	+		
X	oo	oo		X	oo	oo		X	oo	oo	oo	X	oo	X	oo	oo	oo

This exercise is great for developing the ability to switch cleanly between the eighth-note and the sixteenth-note grids. It also develops your ability to use sixteenth notes to fill space between the notes of a pattern to give it a denser texture.

lesson

The offbeats before or after the pulse

You've already worked with the full set of offbeats in four. In this lesson, you'll work with two subsets of those offbeats. The first is the set of offbeats *before* each pulse:

PATTERN 13-1A

1	+	2	+	3	+	4	+	1	+	2	+	3	+	4	+
			X				X				X				X

The pulse is your best reference for playing these notes in time, but you can also use the timeline on the AND of 2 in the first measure to get you started and make sure you stay on track:

PATTERN 13-1B

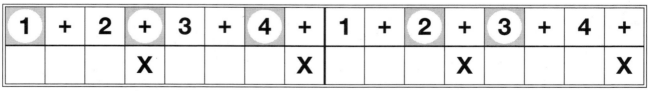

The offbeats before the pulse generate a lot of rhythmic tension. And because these notes are spaced exactly the same distance apart as pulses, if you play this pattern prominently for more than a cycle it can obscure the underlying pulse and may eventually overpower it. This is especially likely when you alternate voices to mimic a pulse-backbeat pattern:

PATTERN 13-2

1	+	2	+	3	+	4	+	1	+	2	+	3	+	4	+
			X				O				X				O

The pitches you use will also affect a listener's perception. If you play this pattern using pitches commonly associated with a pulse-backbeat pattern – like the first and fifth notes of a scale – these offbeats will sound even more like pulses:

PATTERN 13-3

1	+	2	+	3	+	4	+	1	+	2	+	3	+	4	+
			<u>V</u>				I				<u>V</u>				I

Obscuring the pulse is a much more radical effect than simply obscuring the start of the cycle. If listeners and dancers lose track of the start of the cycle, they can always keep moving to the pulse. But if you confuse them about where the pulse is, you may stop them cold. You need to be aware of *the disorienting effect of obscuring the pulse* so you don't unintentionally throw your audience – or the musicians you're playing with.

RHYTHMIC CONCEPT

The disorienting effect of obscuring the pulse

Now fill some space in this pattern by adding an offbeat *after* the pulse on the AND of 3 in the second measure:

PATTERN 13-4

1	+	2	+	3	+	4	+	1	+	2	+	3	+	4	+
			X				X				X		X		X

VARIATION
TECHNIQUE

Attach a prefix

Another way to fill space in the pattern is to *attach a prefix* to one or more of the notes. A **prefix** is simply a note or notes attached before another note or figure. In the next pattern, we've attached a two-note prefix to the note on the AND of 4 in each measure:

PATTERN 13-5

1	+	2	+	3	+	4	+	1	+	2	+	3	+	4	+
			X		O	O	X				X		O	O	X

In the next chart we've built a longer pattern by combining variations of this pattern:

PATTERN 13-6

1	+	2	+	3	+	4	+	1	+	2	+	3	+	4	+
			X		O	O	X				X		O	O	X
			X		O	O	X		O	O	X		O	O	X
			X		O	O	X				X		O	O	X
			X		O	O	X	X			X		O	O	X

Like the set of offbeats before the pulse, the set of offbeats *after* the pulse also has a pulse-obscuring effect:

PATTERN 13-7

1	+	2	+	3	+	4	+	1	+	2	+	3	+	4	+
	X				X				X				X		

In the next chart, we've filled space in this pattern by *attaching a suffix* to the note on the AND of 3 in each measure. A **suffix** is simply a note or notes attached after another note or figure. Notice that the tendency of the largest gap quickly reconfigures the pattern into two parallel figures starting on the AND of 3:

PATTERN 13-8

1	+	2	+	3	+	4	+	1	+	2	+	3	+	4	+
	X				X	O	O		X				X	O	O

In the next exercise, we start with variations of this pattern and then combine variations of three-note figures you've worked with to give you some ideas for ways to improvise:

PATTERN 13-9

1	+	2	+	3	+	4	+	1	+	2	+	3	+	4	+
													X	O	O
	X				X	O	O		X				X	O	O
	X	O	O		X	O	O		X				X	O	O
	X				X	O	O		X				X	O	O
	X	O	O		X	O	O		X				X	O	O
	X	X	X		O	O	O		X	X	X		O	O	O
	X	X	X		O	O	O		X				oo	O	O
	xx	X	X		oo	O	O		xx	X	X		oo	O	O
	xx	X	X		oo	O	O		X						

Notice how much space there is at the start of this pattern. New musicians often get so nervous when it's their turn to take a solo that they try to say too much too soon. When it's your turn, don't be afraid to take your time. Take breaths between phrases. Pause after saying something important to let it sink in. Don't peak too early. Build gradually and end on a high note.

lesson **14**

Timelines

For the sake of simplicity and consistency, we relate all the patterns in four in this book to one timeline, the pattern known in Afro-Cuban music as the son clave. But there are other common timelines in four. In this lesson we show you some. For now, treat them as patterns and play them on your instrument (without listening to the timeline on the CD).

If you have a friend you can play with or a drum machine you can program, you can try any pattern in four with any of these timelines. You can also use these timelines as patterns in your playing, and vary them just as you would any other pattern. But be aware that if you're playing in a traditional context, you should know the specific timeline that goes with the rhythm you're playing.

The first new timeline is called the rumba clave in Afro-Cuban music. It's exactly the same as

the son clave except for one note. In the rumba clave, the third note in the first measure falls on the AND of 4 instead of 4. We've charted both the son clave and the rumba clave below so you can compare the two:

PATTERN 14-1 (SON CLAVE)

1	+	2	+	3	+	4	+	1	+	2	+	3	+	4	+
X				X		X				X		X			

PATTERN 14-2 (RUMBA CLAVE)

1	+	2	+	3	+	4	+	1	+	2	+	3	+	4	+
X				X			X			X		X			

Notice how moving the third note from 4 to the AND of 4 changes the feel of the pattern. The two offbeats in the rumba clave create a suspended feeling until the pattern touches down on 2 in the second measure.

The next timeline is played on a bell in the Ghanaian rhythm gahu (ga-hoo). It's also the same as the son clave except for one note. It differs on the last note, which falls on 4 in the second measure instead of 3:

PATTERN 14-3

1	+	2	+	3	+	4	+	1	+	2	+	3	+	4	+
X				X		X				X				X	

Here's another variation of the son clave that differs only on the last note, which falls on the AND of 3 instead of 3:

PATTERN 14-4

1	+	2	+	3	+	4	+	1	+	2	+	3	+	4	+
X				X		X				X			X		

The next timeline is known as the one-bar clave in Afro-Cuban music, but it's also used widely in rhythms all over the world. It's the same as the first measure of the son clave. Here it is repeated twice:

PATTERN 14-5

1	+	2	+	3	+	4	+	1	+	2	+	3	+	4	+
X			X			X		X				X			X

Here's a timeline that's played on a bell in the Ghanaian rhythm sichi (see-chee). It consists of just three evenly-spaced notes. Be sure to establish the pulse in your body before you start playing it or you'll feel it as three pulses instead of three upbeats:

PATTERN 14-6

1	+	2	+	3	+	4	+	1	+	2	+	3	+	4	+
						X				X				X	

Now let's go back to the son clave. Notice it has 3 notes in the first measure and 2 in the second:

PATTERN 14-7

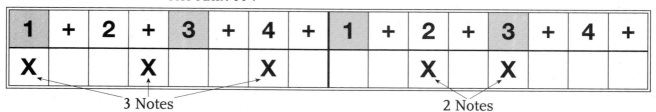

1	+	2	+	3	+	4	+	1	+	2	+	3	+	4	+
X			X			X				X		X			

3 Notes 2 Notes

When the son clave is played with the measures in this order, it's called the 3-2 son clave. When the measures are reversed, the pattern is called the 2-3 son clave because the measure with 2 notes (the "2-

side") comes first and the measure with 3 notes (the "3-side") comes second:

PATTERN 14-8

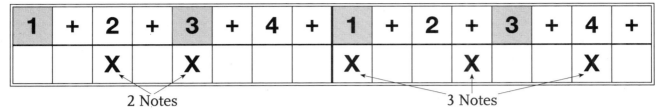

1	+	2	+	3	+	4	+	1	+	2	+	3	+	4	+
		X		X				X				X		X	

2 Notes 3 Notes

The rumba clave – which is in 3-2 form above – can also played in 2-3 form:

PATTERN 14-9

1	+	2	+	3	+	4	+	1	+	2	+	3	+	4	+
		X		X				X				X			X

2 Notes 3 Notes

When you play with others and a clave pattern is used as a timeline, you need to know whether it's a 3-2 or 2-3 clave so you'll know how your part fits and you won't get turned around. A rhythm, melody, or chord progression may fit well with one version of the clave but clash with the other.

Here's a pattern from the Afro-Cuban rhythm called conga that's played with the 2-3 son clave, which we've shaded on the count row. First play the pattern a few times by itself just to get familiar with it. Then turn on the timeline. Because the clave on the CD starts on the 3-side, you'll need to wait a measure to start playing on the 2-side (in a real playing situation, the clave player would start on the 2-side):

PATTERN 14-10

1	+	2	+	3	+	4	+	1	+	2	+	3	+	4	+
X				X				X			O				
X		X		X		X		X			O				

You can also turn the son clave on the CD into other timelines by continuing to shift your perception of where the pattern starts. For example, here's the 3-2 son clave shifted so the first note falls on 3 in the first measure and the last note falls on ONE:

PATTERN 14-11

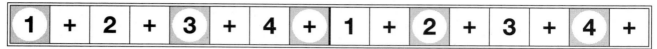

And this is just the beginning. We've only covered three of the sixteen possible transpositions of the son clave. So if you ever feel like playing to a new timeline in four, there are thirteen more waiting for you on the CD.

Pathways through the grid in six

Consecutive eighth-notes in six

You've already played patterns consisting of consecutive eighth notes in four. Now you're going to play them in six. Start by marking the end of each measure with two notes in the alternate voice:

PATTERN 15-1

1	2	3	4	5	6	1	2	3	4	5	6
X	X	X	X	O	O	X	X	X	X	O	O

Now use alternate voicing to create three-note figures that start on each pulse:

PATTERN 15-2

1	2	3	4	5	6	1	2	3	4	5	6
O	O	O	X	X	X	O	O	O	X	X	X

When you shift the pattern one beat to the right, instead of *starting* on a pulse, each set of three notes *ends* on a pulse:

PATTERN 15-3

1	2	3	4	5	6	1	2	3	4	5	6
X	O	O	O	X	X	X	O	O	O	X	X

In the next chart, we've shifted the pattern another beat to the right. Now the pulse falls on the middle note of each three-note figure. If you play the notes evenly, the voicing of this pattern obscures the pulse:

PATTERN 15-4

1	2	3	4	5	6	1	2	3	4	5	6
X	X	O	O	O	X	X	X	O	O	O	X

Now we're going to shift another sequence of consecutive eighth notes. The patterns are based on three-note figures again, but this time each figure contains one O and two X's. In the first pattern, the voicing accents the pulse:

PATTERN 15-5

1	2	3	4	5	6	1	2	3	4	5	6
O	X	X	O	X	X	O	X	X	O	X	X

Now shift this pattern one beat to the right:

PATTERN 15-6

1	2	3	4	5	6	1	2	3	4	5	6
X	O	X	X	O	X	X	O	X	X	O	X

Now shift another beat to the right to create a third version:

PATTERN 15-7

1	2	3	4	5	6	1	2	3	4	5	6
X	X	O	X	X	O	X	X	O	X	X	O

Now join the third version and the first to create a pattern twice as long. Be careful with the transitions between the two:

PATTERN 15-8

1	2	3	4	5	6	1	2	3	4	5	6
O	X	X	O	X	X	O	X	X	O	X	X
X	X	O	X	X	O	X	X	O	X	X	O

In the next pattern, we've created space at the end of a string of consecutive eighth notes:

PATTERN 15-9

1	2	3	4	5	6	1	2	3	4	5	6
X	X	X	X	O	O	O	O	O	X		

When we shift this pattern over three beats so it starts on 4, it ends at the start of the cycle. Use the second pulse in your feet as a reference to find your starting place:

PATTERN 15-10

1	2	3	4	5	6	1	2	3	4	5	6
			X	X	X	X	O	O	O	O	O
X											

RHYTHMIC
CONCEPT

The stabilizing effect
of ending on ONE

We added an empty cycle after the last note of this pattern so you could really feel *the stabilizing effect of ending on* ONE. This effect is especially welcome when a pattern throws listeners temporarily off balance. Ending on ONE restores a sense of stability and groundedness, and a feeling that the pattern has come home. It's like putting a period at the end of a sentence.

If you don't want to create such a strong sense of resolution, just add a note on the beat after ONE:

PATTERN 15-11

1	2	3	4	5	6	1	2	3	4	5	6
			X	X	X	X	O	O	O	O	O
X	X										

When you add the note on the beat after ONE to your ending, you're like a parachutist who hits the ground and then rolls to soften the force of the landing. Because this creates a more diffuse ending to a pattern, we call it *the diffusing effect of ending on the beat after ONE*.

Another way to end a pattern without a strong sense of resolution is to stop just before you get to ONE. We call this *the suspended effect of ending on the beat before ONE*:

PATTERN 15-12

1	2	3	4	5	6	1	2	3	4	5	6
			X	X	X	X	O	O	O	O	X

Drumset players often accent the beat before ONE with a cymbal crash. This creates a kind of sonic mist that gradually disperses, allowing the groove to re-emerge a few beats later.

RHYTHMIC CONCEPT

The diffusing effect of ending on the beat after ONE

RHYTHMIC CONCEPT

The suspended effect of ending on the beat before ONE

lesson

The odd-numbered beats – the 6-pulse and 3 over 2

In this lesson, we use the odd-numbered beats to introduce a new pulse in six and the polyrhythm 3 over 2. In the next lesson, you'll learn patterns based on the odd-numbered beats.

Until now, the pulse you've been using with patterns in six has fallen on beats 1 and 4 in each measure. Because it has 4 pulses to a cycle we call it the **4-pulse** (this also describes the pulse we've been using in four). Another common pulse in African and Afro-Cuban rhythms in six falls on the odd-numbered beats in each measure. Because it has 6 pulses to a cycle we call it the **6-pulse**. To feel this pulse, tap the odd-numbered beats in your feet while you count out loud (you won't the need the CD for a while):

PATTERN 16-1

1	2	3	4	5	6	1	2	3	4	5	6
🦶		🦶		🦶		🦶		🦶		🦶	

If you alternate feet on each pulse, notice that one foot taps the 1 in the first measure and the other foot taps the 1 in the second.

In the next chart, we've shaded the 6-pulse on the count row and put the timeline on the bottom row. Notice how the two patterns fit together. The first three notes (on 1, 3, and 5) are the same in both patterns. Then on 6 in the first measure, the timeline switches to even-numbered beats and dances around the pulse until the patterns meet again at the start of the cycle. Now tap the 6-pulse in your feet as you play or clap the timeline:

PATTERN 16-2

1	2	3	4	5	6	1	2	3	4	5	6
X		X		X	X		X		X		X

When the pulse falls on the odd-numbered beats, the even-numbered beats become upbeats (because they fall midway between each two pulses). You may find it helpful to think of the timeline's relationship to the 6-pulse as "pulse, pulse, pulse-up, up, up, up-pulse ..."

To hear the contrast even more distinctly between the pulses and upbeats in the timeline, play it with two voices:

PATTERN 16-3

1	2	3	4	5	6	1	2	3	4	5	6
X		X		X	O		O		O		O

You'll find that certain patterns in six are easier to play with a 6-pulse than a 4-pulse. You may even have felt that with the timeline pattern you just played, which strongly implies a 6-pulse. But even if a 6-pulse doesn't make a pattern easier to play, it will always give you a fresh perspective on a pattern.

So go ahead and try tapping the 6-pulse instead of the 4-pulse with any pattern in six. But for the sake of consistency, we're going to continue presenting rhythms in six with a 4-pulse. Most of the music you'll be playing will probably have a 4-pulse too.

In the next chart, you'll see the 4-pulse back on the count row. The set of odd-numbered beats that was the 6-pulse has now become the pattern on the row under it. Tap the 4-pulse in your feet and then clap the odd-numbered beats:

PATTERN 16-4

1	2	3	4	5	6	1	2	3	4	5	6
X		X		X		X		X		X	

Notice that hands and feet come together on 1 but that the foot on 4 comes down *between* the notes in your hands on 3 and 5. The pattern goes "together-hand-foot-hand, together-hand-foot-hand."

In each measure of this pattern, you clapped 3 times for every 2 taps in your feet. This 3 over 2 rhythm – or 6 over 4 if you put both measures together – is a **polyrhythm**. By our definition, a polyrhythm is created when two patterns are perceived at the same time that *a)* create or imply uneven pulses *or b)* have uneven grids.

Two pulses are **uneven pulses** if neither contains all the notes of the other (when the two are started together). The 4-pulse created by the 2 and the 6-pulse implied by the 3 above are uneven because – although they start together and share a note on 1 – neither contains all the notes of the other. We'll get to uneven grids in chapter 12.

When two patterns have uneven pulses, one pattern will usually feel like it creates or implies the underlying pulse. The other pattern – called the **counter-rhythm** – will be perceived as being played *over* that pattern.

We called the pattern above "3 *over* 2" because the 2 in your feet is felt as the underlying pulse while the 3 is perceived as the counter-rhythm. Remember that since we indicate the underlying pulse on the count row, a pattern felt "over" it will appear *under* it on our charts. We considered flipping the charts and putting the count row on the bottom, but this made them harder to read. Once you put the two patterns in your hands and feet, it'll be clear which end is up.

When the 3 is perceived as the underlying pulse and the 2 as the counter-rhythm, the polyrhythm is called "2 over 3." You can feel this polyrhythm by tapping the 3 in your feet and clapping the 2:

PATTERN 16-5

1	2	3	4	5	6	1	2	3	4	5	6
X			X			X			X		

Sometimes your perception of which pattern is over which can shift. Try this experiment. Put your hands where you can make a different sound with each one. Then tap 3 in one hand (beats 1, 3, and 5) and 2 in the other (beats 1, 4):

PATTERN 16-6

1	2	3	4	5	6	1	2	3	4	5	6
X		X		X		X		X		X	
X			X			X			X		

Once you can tap the pattern comfortably, focus your awareness on one hand for a while. Then shift your awareness to the other hand and notice what happens to your perception of which is the underlying pulse.

You can also put the 3 and the 2 together to create one **composite pattern** by playing all the notes of both patterns with the same sound without doubling the notes on beats where the two patterns coincide:

PATTERN 16-7

1	2	3	4	5	6	1	2	3	4	5	6
X		X	X	X		X		X	X	X	

Learning the composite pattern is one way to make remembering a polyrhythm easier. But while the two patterns are in their composite form, they stop being a true polyrhythm because they've merged into a single pattern.

lesson

The odd-numbered beats – patterns

Now that you're familiar with the odd-numbered beats in six, you're ready to start playing variations. First warm up by playing the basic pattern with a 4-pulse in your feet, adding the timeline on the CD when you're ready for triple-weave practicing:

PATTERN 17-1

1	2	3	4	5	6	1	2	3	4	5	6
X		X		X		X		X		X	

Now change the voicing and fill the space on 6 in each measure:

PATTERN 17-2

1	2	3	4	5	6	1	2	3	4	5	6
X		X		O	O	X		X		O	O

Now leave out the note on 1 in each measure to create a pattern common in African and Afro-Cuban rhythms in six:

PATTERN 17-3A

1	2	3	4	5	6	1	2	3	4	5	6
		X		O	O			X		O	O

Although none of the notes of this pattern coincide with the pulse, several coincide with the timeline:

PATTERN 17-3B

1	2	3	4	5	6	1	2	3	4	5	6
		X		O	O			X		O	O

In the next chart we've built a longer pattern by substituting a pair of O's for the X in the last measure:

PATTERN 17-4

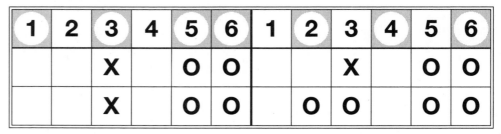

1	2	3	4	5	6	1	2	3	4	5	6
		X		O	O			X		O	O
		X		O	O	O	O			O	O

The next pattern is a combination of two different patterns within a single cycle. The first measure consists of odd-numbered beats and the second consists of two parallel pairs:

PATTERN 17-5

1	2	3	4	5	6	1	2	3	4	5	6
X		O		X			O	O		O	O

In the second measure of the next combination, we've used a three-note figure:

PATTERN 17-6

1	2	3	4	5	6	1	2	3	4	5	6
X		O		X			O	O	X		

Now we've combined these combinations and varied them to create a longer pattern:

PATTERN 17-7

1	2	3	4	5	6	1	2	3	4	5	6
X		O		X			O	O		O	O
X		O		X			O	O	X		O
X		O		X			O	O		O	O
X		O		X			O	O	X		O
X		O		X			O	O	X		
	O	O	X				O	O	X		
X		O		X			O	O	X		
	O	O	X				O	O	X		
X		O		X		o o	O	O	o o	O	O
X		O		X		o o	O	O	o o	O	O
X		O		X		o o	O	O	o o	O	O
x x	X	X	o o	O	O	x x	X	X	o o	O	O
X		O		X		O		X		O	
X		O		X		O		X		O	
X	X										

You may have noticed in rows 5 through 8 of this pattern that the repeated three-note figures seem to imply a **2-pulse**. A 2-pulse falls only on beat 1 in each measure (in four *or* six) and creates what's called a **half-time** feel. The 2-pulse is common in both African and Afro-Cuban music. Although it gives you fewer reference points than

the 4-pulse, it creates a more relaxed feel even when the timeline starts to move at a frantic pace. You can try tapping a 2-pulse with any pattern in this book. But for consistency, we'll continue to relate most patterns to a 4-pulse.

lesson

The even-numbered beats

The full set of even-numbered beats in six can be tricky to play at first, so you may want to hold off playing while you take the time to understand how they fit with the pulse and the timeline. How the even-numbered beats are categorized depends on where the pulse is. With a 6-pulse on the odd-numbered beats, the even-numbered beats fall midway between pulses, so they're upbeats:

PATTERN 18-1A

1	2	3	4	5	6	1	2	3	4	5	6
	X		X		X		X		X		X

With a 4-pulse, the even-numbered beats fall into two categories. Beats 2 and 6 are offbeats and beat 4 is a pulse:

PATTERN 18-1B

1	2	3	4	5	6	1	2	3	4	5	6
	X		X		X		X		X		X

Notice that the even-numbered beats create a shifted 6-pulse (starting on 2) that forms a polyrhythm with the underlying 4-pulse. You can see the 3 over 2 relationship more clearly if you think of the pattern as starting on 4.

Notice also that from 6 in the first measure to 6 in the second, the set of even-numbered beats and the notes of the timeline are identical:

PATTERN 18-1C

1	2	3	4	5	6	1	2	3	4	5	6
	X		X		X		X		X		X

If you have trouble playing the set of even-numbered beats at the triple-weave level, you can always take out the timeline or go back to say-it-and-play-it. Playing ghost notes on the odd-numbered beats can help too.

Now play the even-numbered beats for a cycle and end on a stabilizing note on ONE. Then rest for a cycle before tackling the even-numbered beats again:

PATTERN 18-2

1	2	3	4	5	6	1	2	3	4	5	6
	X		X		X		X		X		X
X											

Here's a cycle of even-numbered beats combined with a measure of pattern 6-15:

PATTERN 18-3

1	2	3	4	5	6	1	2	3	4	5	6
	X		X		X		X		O	O	O

Here's a variation of this pattern that starts with a full row of pattern 6-15:

PATTERN 18-4

1	2	3	4	5	6	1	2	3	4	5	6
	X		O	O	O		X		O	O	O
	X		X		X		X		O	O	O

Now create some space in the set of even- numbered beats by substituting ghost notes for the notes on 4. This creates two parallel figures consisting of the offbeats on 6 and 2. Because these figures surround but do not touch the pulse on 1 in each measure, they obscure the start of the cycle *and* the pulse:

PATTERN 18-5

1	2	3	4	5	6	1	2	3	4	5	6
	X		•		X		X		•		<u>X</u>

When you're ready, take out the ghost notes and alternate voices. The result is a lead drum pattern found in the Ghanaian rhythm kpegisu (peh-gee-soo). We've put the timeline on the count row so you can see how this pattern relates to it:

PATTERN 18-6

1	2	3	4	5	6	1	2	3	4	5	6
	X				O		X				<u>O</u>

One way to vary this pattern is by attaching a prefix to the note on 6 in the first measure (notice that the pulse is back on the count row):

PATTERN 18-7

1	2	3	4	5	6	1	2	3	4	5	6
	X		O	O	O		X				<u>O</u>

Next combine variations to build a longer pattern (notice the pattern starts on the last note of the chart):

PATTERN 18-8

1	2	3	4	5	6	1	2	3	4	5	6
	X				O	X					O
	X		O	O	O	X					O
	X				O	X					O
	X		O	O	O	X					O
	X		O	O	O	X			O	O	O
	X		O	O	O	X					<u>O</u>

Don't be surprised if the last few rows of this pattern make the timeline turn around on you. You're just experiencing the disorienting effect of a pattern that obscures *both* the pulse and the start of the cycle.

lesson

Backbeats

It's time again to emphasize the backbeat, which we defined in lesson 11 as every second pulse. In four, the backbeats fell on beat 3

in each measure. In six, with a 4-pulse on beats 1 and 4, the backbeats fall on beat 4:

PATTERN 19-1A

1	2	3	4	5	6	1	2	3	4	5	6
			X						X		

Notice that while the backbeat in the first measure falls in between two notes in the timeline, the backbeat in the second measure coincides with a note in the timeline:

PATTERN 19-1B

1	2	3	4	5	6	1	2	3	4	5	6
			X						X		

In the following patterns, you're going to emphasize the backbeats in the X voice while playing variations around them with the alternate voice. If you want, you can think of yourself as a drumset player again, with the X as a rimshot on a snare drum and the O as a note on a bass drum. Start by adding a pair of O's on ONE and the beat before it:

PATTERN 19-2

1	2	3	4	5	6	1	2	3	4	5	6
O			X						X		O

Next add another pair of O's:

PATTERN 19-3

1	2	3	4	5	6	1	2	3	4	5	6
O			X		O	O			X		O

In popular music this rhythm is called a shuffle.

Now take out the note on 1 in the second measure:

PATTERN 19-4

1	2	3	4	5	6	1	2	3	4	5	6
O			X		O				X		O

Now take out the note on ONE instead, so the pattern creates the suspended effect of ending on the beat before ONE:

PATTERN 19-5

1	2	3	4	5	6	1	2	3	4	5	6
			X		O	O			X		O

In the next pattern there are two pairs of O's again. Notice that the pair in the middle of the cycle is shifted to start on 1 in the second measure:

PATTERN 19-6

1	2	3	4	5	6	1	2	3	4	5	6
O			X			O	O		X		O

Here are two variations built around the backbeats by adding notes from the set of odd-numbered beats:

PATTERN 19-7

1	2	3	4	5	6	1	2	3	4	5	6
O		O	X						X	O	

PATTERN 19-8

1	2	3	4	5	6	1	2	3	4	5	6
			X	O		O			O	X	

In the next variation, the odd-numbered beats in the alternate voice create the polyrhythm of 3 over 2:

PATTERN 19-9

1	2	3	4	5	6	1	2	3	4	5	6
O		O	X	O		O		O	X	O	

Now create space in this pattern to keep the polyrhythm from taking over:

PATTERN 19-10

1	2	3	4	5	6	1	2	3	4	5	6
O		O	X			O		O	X		
O		O	X	O		O		O	X		

In the next pattern, we've filled in even-numbered beats in the alternate voice and ended the pattern on a stabilizing note on ONE. We've shaded the timeline on the count row so you can see how the pattern fits with it:

PATTERN 19-11

1	2	3	4	5	6	1	2	3	4	5	6
O			X		O	O		X			O

In the next pattern, both figures start on backbeats and overlap the bar lines:

PATTERN 19-12

1	2	3	4	5	6	1	2	3	4	5	6
O	O		X	O	O	O	O		X	O	O

Start playing this next pattern on 2 in the first measure, and notice after several repetitions how you perceive it:

PATTERN 19-13

1	2	3	4	5	6	1	2	3	4	5	6
	O	O	X		O		O	O	X		O

RHYTHMIC
CONCEPT

The tendency to
group notes in the
same voice together

Did you start to hear the pattern as two parallel figures beginning on 6 in each measure? If you did, it's probably because of the ear's *tendency to group notes in the same voice together*. You can use this concept to create figures that overlap the bar line and obscure the start of the cycle.

lesson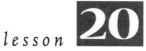

The offbeats before or after the pulse

In six, with a 4-pulse, beats 2, 3, 5, and 6 are all offbeats. The offbeats *before* the pulse fall on beats 3 and 6:

PATTERN 20-1A

1	2	3	4	5	6	1	2	3	4	5	6
		X			X			X			X

Three of these notes coincide with notes in the timeline:

PATTERN 20-1B

1	2	3	4	5	6	1	2	3	4	5	6
		X			X			X			X

Like any set of notes spaced the same distance apart as pulses, these notes can obscure the pulse or establish a competing pulse, depending on how long they're played, how prominently, and with what pitches. Keep that in mind when you consider using the full set in your

playing, especially if you use alternating voices that mimic a pulse-backbeat pattern:

PATTERN 20-2

1	2	3	4	5	6	1	2	3	4	5	6
		X			O			X			O

You can create interesting patterns by playing the full set of these offbeats with one voice while filling space with the alternate voice. Start by filling space to create two figures that overlap the bar lines:

PATTERN 20-3

1	2	3	4	5	6	1	2	3	4	5	6
O	O	X			X	O	O	X			X

Now create a longer pattern:

PATTERN 20-4

1	2	3	4	5	6	1	2	3	4	5	6
O	O	X			X	O	O	X			X
O	O	X	O	O	X	O	O	X			X

The offbeats *after* the pulse fall on beats 2 and 5:

PATTERN 20-5A

1	2	3	4	5	6	1	2	3	4	5	6
	X			X			X			X	

This set coincides with the timeline on 5 in the first measure and 2 in the second:

PATTERN 20-5B

1	2	3	4	5	6	1	2	3	4	5	6
	X			X			X			X	

Here's the pattern with alternating voices:

PATTERN 20-6

1	2	3	4	5	6	1	2	3	4	5	6
	O			X			O			X	

In the next pattern, we've filled the space between the notes on 2 and 5 in each measure:

PATTERN 20-7

1	2	3	4	5	6	1	2	3	4	5	6
	O	O	O	X			O	O	O	X	

Now substitute two sixteenth notes for the first eighth note in each figure:

PATTERN 20-8

1	2	3	4	5	6	1	2	3	4	5	6
	oo	O	O	X			oo	O	O	X	

In the next chart, we've varied the pattern in the second cycle to create one long figure:

PATTERN 20-9

1	2	3	4	5	6	1	2	3	4	5	6
	oo	O	O	X			oo	O	O	X	
	oo	O	O	oo	O	O	oo	O	O	X	

Next we've used the alternate voice to fill the space between the offbeats after the pulse and create figures that overlap the bar lines:

PATTERN 20-10

1	2	3	4	5	6	1	2	3	4	5	6
O	X			<u>X</u>	O	O	X			X	O

This pattern can be particularly hard to keep under control. If you don't keep a close eye on those X's, they can disguise themselves as pulses and turn the timeline around on you. Or the timeline will stay put but the X's will actually slide onto the pulses, so you're playing them on 4 and 1 instead of 5 and 2. Go ahead and accent the pulses on 1 if you need to at first. But then gradually wean yourself from the accents, until you can play every note in the pattern evenly without losing your bearings.

lesson

Singles and pairs and timelines

Singles and pairs in six are even simpler than they are in four. Just play any combination of three singles and two pairs and you'll end up back where you started in the next cycle.

The best example of a singles and pairs pattern in six is the timeline you've been using all along:

PATTERN 21-1

1	2	3	4	5	6	1	2	3	4	5	6
X		X		X	X		X		X		X

Remember how pairs in four switched you from numbered beats to offbeats or vice versa? In six, pairs switch you from odd-numbered beats to even or vice versa. If the last single you played was on an odd-numbered beat – like the single on 3 in the first measure above – a pair will switch you to the even-numbered beats. That's what the pair starting on 5 in the first measure does. If the last single you played was on an even-numbered beat – like the single on 4 in the second measure above – a pair will switch you to the odd-numbered beats. That's what the pair starting on 6 in the second measure does.

The next singles and pairs pattern is widely used as a timeline in African rhythms and other rhythms around the world. It's sometimes referred to as "the long bell," probably because there's a longer distance to the first pair than there is in "the short bell" (the timeline we've been using throughout the book). Play it now without turning on the CD:

PATTERN 21-2

1	2	3	4	5	6	1	2	3	4	5	6
X		X		X		X	X		X		X

If you've ever gotten lost while listening to the timeline in six on the CD you may have started perceiving it as this pattern. That's because the long bell is a shifted version of the short bell:

Short bell starts here ↓

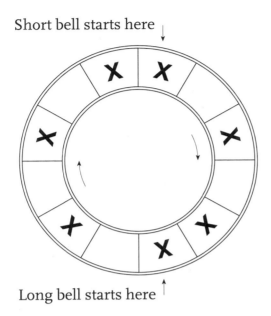

Long bell starts here ↑

You can use the long bell as a timeline with any pattern in six. And you can use the timeline CD to create the long bell by simply changing where you hear the start of the cycle and where you put the pulse.

The long bell starts on the note on 6 in the first measure of the short bell. Notice that that note does *not* fall on a pulse in the short bell. To convert that note into the first note of the long bell, you need to put the first pulse there:

SHORT BELL

1	2	3	4	5	6	1	2	3	4	5	6
X		X		X	X		X		X		X

LONG BELL

1	2	3	4	5	6	1	2	3	4	5	6
X		X		X		X	X		X		X

Now turn on the timeline and let it go for a while until you start hearing the long bell pattern. If you can't pick it out easily, it may help to remember that both the short bell and the long bell start on the second note of a pair. So if one pair doesn't work, wait for the next pair and start the long bell on the second note.

Once you're hearing the timeline as the long bell, add the relocated pulse in your feet. Then you can try playing any of the patterns in six in this book with the long bell as the timeline. For example, here's a drum part from the Haitian rhythm mai (mah-ee), which – like many Haitian rhythms – uses the long bell as the timeline:

PATTERN 21-3

1	2	3	4	5	6	1	2	3	4	5	6
O	O			X	X	O			X		X

The next singles and pairs pattern is a variation of the short bell that ends on 4 in the second measure:

PATTERN 21-4

1	2	3	4	5	6	1	2	3	4	5	6
X		X		X	X		X		X		

The next pattern is also a variation of the short bell with a note on 5 instead of 6 in the second measure:

PATTERN 21-5

1	2	3	4	5	6	1	2	3	4	5	6
X		X		X	X		X		X	X	

The next pattern starts with a pair on the first two beats of the cycle. It's the long bell with the second measure first, like a 2-3 clave pattern:

PATTERN 21-6

1	2	3	4	5	6	1	2	3	4	5	6
X	X		X		X	X		X		X	

If you put the second measure of the *short* bell first, there's no note on ONE:

PATTERN 21-7

1	2	3	4	5	6	1	2	3	4	5	6
	X		X		X	X		X		X	X

You can use this pattern and all the other shifted versions of the 6/8 bell as timelines simply by changing where you hear the start of the pattern on the CD.

If you take out the first note of each pair in the short bell, you get the essence of that timeline, a pattern referred to in Afro-Cuban music as the 6/8 clave. You played this pattern way back in lesson 1:

PATTERN 21-8

1	2	3	4	5	6	1	2	3	4	5	6
X		X			X		X		X		

Taking out the first note of each pair in the long bell gives you the essence of that timeline:

PATTERN 21-9

1	2	3	4	5	6	1	2	3	4	5	6
X		X		X			X		X		

The next pattern is another variation of the long bell. The notes in the first measure create a 6-pulse while the notes in the second measure track the 4-pulse:

PATTERN 21-10

1	2	3	4	5	6	1	2	3	4	5	6
X		X		X		X			X		

The timeline for the Ghanaian rhythm adowa has only four notes. Notice that the pattern starts on 5 in the first measure and ends on ONE:

PATTERN 21-11

1	2	3	4	5	6	1	2	3	4	5	6
X				X		X			X		

W e've always agreed that if our house were on fire and we could only take one rhythm with us, the short bell would definitely be it. Then a couple years ago, Ken Dalluge, a percussionist from Santa Cruz, blew us away by pointing out the correspondence between the structure of this universal rhythmic pattern and the structure of the major scale.

This correspondence is easiest to understand if you think of the boxes on a chart in six as the keys on a piano, with the box on ONE as middle C. The notes of the bell pattern on the chart match the white keys on the piano. Where there's an empty box on the chart, there's a black key on the piano.

This correspondence is either one of the most amazing coincidences in the history of the planet or it reflects a mysterious underlying unity between tonality and rhythm.

Three not-quite-equal groups of beats in four

One-bar clave patterns

In six, the odd-numbered beats divide a measure evenly into three groups of two beats:

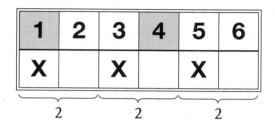

In four, you can't divide a measure evenly into three sections. The closest you can come on our grid is to divide the eight beats of a measure into two sections of three beats and one section of two. That's what the following pattern does:

PATTERN 22-1

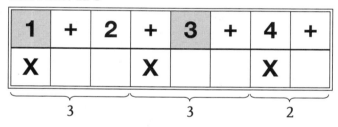

This pattern is found all over the world. In Afro-Cuban music it's called the one-bar clave, which is the name we'll use for it. As we mentioned in the lesson on timelines in four, the one-bar clave is the first half of the son clave. Here's the one-bar clave repeated twice over two measures:

PATTERN 22-2

1	+	2	+	3	+	4	+	1	+	2	+	3	+	4	+
X			X		X			X			X		X		

This pattern is like a wheel that's not quite round; it's got a hitch in it. Because it starts with a note on every third beat – 1, the AND of 2, 4 – it feels temporarily like a pattern in six. Then comes the hitch, and the pattern abruptly starts over again on 1. This hitch, this uneven-ness, gives the pattern its tremendous vitality and power.

Let's explore some of its possibilities. Start by creating a space in the pattern (even though the one-bar clave is itself a timeline, the patterns here work well with the timeline on the CD): *[handwritten: Start B ↓]*

PATTERN 22-3

1	+	2	+	3	+	4	+	1	+	2	+	3	+	4	+
X			X			X		X						X	

[handwritten ✗ in right margin]

PATTERN 22-4

1	+	2	+	3	+	4	+	1	+	2	+	3	+	4	+
X			X			X								X	

Next try emphasizing one of the notes in the one-bar clave by playing it with the alternative voice:

PATTERN 22-5

1	+	2	+	3	+	4	+	1	+	2	+	3	+	4	+
X			O			X		X			O			X	

PATTERN 22-6

1	+	2	+	3	+	4	+	1	+	2	+	3	+	4	+
X			X			O		X			X			O	

By creating space in this last pattern, you can arrive at the conga melody for the rumba guaguanco (wah-wahn-koh):

PATTERN 22-7

1	+	2	+	3	+	4	+	1	+	2	+	3	+	4	+
X			X			O									O

You can also start the melody for the rumba guaguanco on 4 in the first measure:

PATTERN 22-8

1	+	2	+	3	+	4	+	1	+	2	+	3	+	4	+
						O		X				X		O	

Now change the voicing so it's different in each measure:

PATTERN 22-9

1	+	2	+	3	+	4	+	1	+	2	+	3	+	4	+
X				O		X		O				X		O	

PATTERN 22-10

1	+	2	+	3	+	4	+	1	+	2	+	3	+	4	+
X				X		O		O				X		X	

Here are a couple of common patterns that could be interpreted as the one-bar clave pattern with prefixes or suffixes added:

PATTERN 22-11

1	+	2	+	3	+	4	+	1	+	2	+	3	+	4	+
X				X	X	X		X				X	X	X	

1	+	2	+	3	+	4	+	1	+	2	+	3	+	4	+
X		X	X		X	X		X		X	X		X	X	

Here's a pattern found in many West-African rhythms that can be created by adding a note on 2 to the one-bar clave pattern in each measure. Notice that it starts on 4 in the second measure:

1	+	2	+	3	+	4	+	1	+	2	+	3	+	4	+
X		O	O			X		X		O	O			X̲	

Now try some variations:

1	+	2	+	3	+	4	+	1	+	2	+	3	+	4	+
														X	
X		O	O			X		X		O	O			X	
X		O		O	O	X		X		O	O			X	X
X		O	O		X	X		X		O	O			X	X
X		O		O	O	X	X	X		O	O			X	X
O		O	O			X	X	O		O	O			X	X
O		O		O	O	X	X	O		O	O			X	X
						X	X	O		O	O			X	X
						X	X	O		O	O			X	X

One interesting way to generate a new pattern is to play the **reverse image** of a pattern you already know. To do this, just play notes where there are empty beats in the original pattern and leave out all the original notes. In the next chart, the reverse image of the one-bar clave appears on the bottom row. The one-bar clave appears above it so you can see how we got the reverse image, but you only need to play the bottom row:

PATTERN 22-15

1	+	2	+	3	+	4	+	1	+	2	+	3	+	4	+
X			X			X		X			X			X	
	X	X		X	X		X		X	X		X	X		X

Playing a reverse image is easy if your instrument will allow you to play the original pattern in one hand while tapping the empty beats as ghost notes in the other. Then you can simply increase the volume of the ghost-note hand while decreasing the volume of the hand playing the original pattern. At that stage it should be easy to let go of the original pattern and shift entirely to the reverse image.

lesson **23**

Shifted one-bar clave patterns

In this lesson, you're going to take the one-bar clave pattern and shift it. You'll also combine it with other patterns you've learned and get to practice applying some of the variation techniques you know.

Here's the one-measure pattern shifted a beat to the right and played only once in a two-measure cycle:

PATTERN 23-1

1	+	2	+	3	+	4	+	1	+	2	+	3	+	4	+
	X			X			X								

Structurally, the one-bar clave pattern is like a sandwich. If it starts on an offbeat (as in pattern 23-1) it ends on an offbeat, with a numbered beat in the middle. If it starts on a numbered beat (as in the next chart, where we've shifted it a beat to the right) it ends on a numbered beat, with an *offbeat* in the middle:

PATTERN 23-2

1	+	2	+	3	+	4	+	1	+	2	+	3	+	4	+
		X		X				X							

In the next chart, we repeat this pattern twice in the two-measure cycle. Once you start playing it, notice how quickly your perception of where it starts changes from 2 to 1. There are a couple reasons for this. First, the tendency of the largest gap is a factor – the note on 2 follows the *smallest* gap. And although the notes on the AND of 3 and 1 both follow gaps of the same size, the notes on 1 quickly win out because they coincide with the pulse and the start of the timeline:

PATTERN 23-3

1	+	2	+	3	+	4	+	1	+	2	+	3	+	4	+
X		X̲		X				X		X		X			

There's no reason to fight this change in perception if it happens. As long as you can come in and get out when you're supposed to and keep track of where you are along the way, you can hear the pattern any way you want.

Now we've shifted the one-measure pattern another beat to the right and started it on the AND of 2. Notice that the first two notes of the pattern coincide with the timeline:

PATTERN 23-4

1	+	2	+	3	+	4	+	1	+	2	+	3	+	4	+
			X			X		X							

In the next chart we've filled space in this pattern by adding a contrasting sequence of three numbered beats that ends on ONE (notice the pulse is back on the count row):

PATTERN 23-5

1	+	2	+	3	+	4	+	1	+	2	+	3	+	4	+
O				X̲		X		X				O		O	

Here's the one-bar clave pattern starting on the AND of 2 repeated twice. We've underlined the AND of 2 again so you can continue to track the transposition of the pattern, but once you start repeating it, you'll hear the starting point of the figures as the AND of 1:

PATTERN 23-6

1	+	2	+	3	+	4	+	1	+	2	+	3	+	4	+
	X		X̲			X			X		X			X	

Now fill some space in this pattern:

PATTERN 23-7

1	+	2	+	3	+	4	+	1	+	2	+	3	+	4	+
	X		X	O	O	X			X		X	O	O	X	

When you shift the two-measure pattern over to start on the AND of 3, the note that ends up on ONE will take over as the starting point as soon as you play it:

PATTERN 23-8

1	+	2	+	3	+	4	+	1	+	2	+	3	+	4	+
X			X		X̲			X			X		X		

Now try combining this pattern with a couple others:

PATTERN 23-9

1	+	2	+	3	+	4	+	1	+	2	+	3	+	4	+
X			X		X			X			X		X		
X		X	O	O				X			X		X		
X			X		X			X			X		X		
X		X	O	O				X			X		X		
X		X	oo	O	O	O	O	X			X		X		
X		X	oo	O	O	O	O	X			X		X		
X		X	oo	O	O	O	O	X			O		O		X
	O		X		O		X		X	O	O	X	X		

You can keep going from here. Try out the rest of the shifted versions to find the ones you like best. Then experiment with those using the variation techniques you know. Then combine the variations with other patterns. This is how you create your own personal rhythmic vocabulary.

lesson

5/5/6 patterns

You can't evenly divide two measures of four – 16 beats – into three equal groups. The closest you can get on our grid is three not-quite-equal groups of 5, 5, and 6 beats in any combination: 5/5/6, 6/5/5, or 5/6/5. Occasionally – as in the title of this lesson – we use the phrase "5/5/6 patterns" as a shorthand way to refer to all of these combinations.

Patterns based on these uneven groupings have a hitch in them like the hitch in the one-bar clave. But the hitch is more subtle because the groups are proportionately closer to being equal in size. In this lesson, you'll play a variety of patterns starting on ONE that create these uneven groups of beats.

Here's an example of a 5/5/6 pattern starting on ONE:

PATTERN 24-1

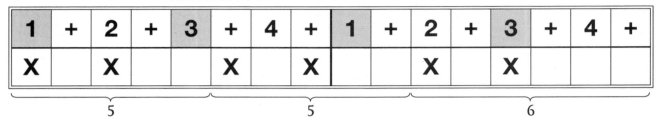

Now, using the same figures, take the group of 6 beats and put it first to create a 6/5/5 pattern:

PATTERN 24-2

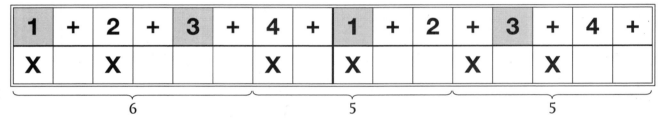

Even though the largest gap in this pattern comes before 4 in the first measure, it probably won't change your perception of where the pattern starts. This largest gap is only slightly larger than the other gaps in the pattern, and the note in the first figure on ONE reinforces the sense that the pattern starts there. The same is true for similar patterns throughout this lesson.

Now put the group of 6 beats in the middle to create a 5/6/5 pattern:

PATTERN 24-3

1	+	2	+	3	+	4	+	1	+	2	+	3	+	4	+
X		X			X		X				X		X		

　　　　5　　　　　　　　　　6　　　　　　　　　　5

The next three patterns use figures consisting of a single and a pair. Here's the 5/5/6 pattern using these figures:

PATTERN 24-4

1	+	2	+	3	+	4	+	1	+	2	+	3	+	4	+
X		X	X		X		X	X		X		X	X		

This pattern is another cascara pattern, often played with sticks on the shell of a timbale.

Here are the same figures in 6/5/5 and 5/6/5 form:

PATTERN 24-5

1	+	2	+	3	+	4	+	1	+	2	+	3	+	4	+
X		X	X			X		X	X		X		X	X	

PATTERN 24-6

1	+	2	+	3	+	4	+	1	+	2	+	3	+	4	+
X		X	X		X		X	X			X		X	X	

In the next chart we've used the alternate voice on the pairs in the 5/5/6 pattern to make the figures stand out. Once you've tried it, go back and change the voicing on the other two patterns:

PATTERN 24-7

1	+	2	+	3	+	4	+	1	+	2	+	3	+	4	+
X		O	O		X		O	O		X		O	O		

Now switch to figures consisting of three consecutive notes. We've charted the 5/5/6 pattern for you. It may help to notice the relationship

of each figure to the pulse. The first figure starts on a pulse, the second falls between two pulses, and the third ends on a pulse:

PATTERN 24-8

1	+	2	+	3	+	4	+	1	+	2	+	3	+	4	+
X	X	X			X	X	X			X	X	X			

Now rearrange the groupings and play the 5/6/5 and 6/5/5 patterns using these same figures. Then change the voicing.

We use two voices on the four-note figures in next 5/5/6 pattern. After you've played it, rearrange the groupings and change the voicing:

PATTERN 24-9

1	+	2	+	3	+	4	+	1	+	2	+	3	+	4	+
X	X	O	O		X	X	O	O		X	X	O	O		

In the first cycle in next chart, we start with two parallel figures. In the second cycle, we bring the figures closer together, so that three figures fit within the cycle in a 5/5/6 pattern:

PATTERN 24-10

1	+	2	+	3	+	4	+	1	+	2	+	3	+	4	+
X		O	O					X		O	O				
X		O	O		X		O	O		X		O	O		

VARIATION
TECHNIQUE

Compress

We call the technique of taking out space between (or within) figures **compressing**. *Compressing* is a great technique for building rhythmic excitement. The figures grow more insistent with each compression. Before you move on, pick any pattern you like with a short repeating figure and try compressing it. If it helps to write the pattern down, you can use one of the blank charts at the back of the book.

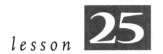

lesson

Shifted 5/5/6 patterns

In the last lesson, when we presented patterns starting on ONE that divided 16 beats into three not-quite-equal groups, we found it helpful to label the patterns 5/5/6, 6/5/5, or 5/6/5 according to the arrangement of the groups. For any particular pattern, these three arrangements are actually shifted versions of each other.

In this lesson, you're going to play variations of the same patterns starting somewhere other than ONE. For example, here's a 5/5/6 pattern of three-note figures shifted one beat to the right. Notice that the last group of 6 beats gets split between the end of the second measure and the beginning of the first:

PATTERN 25-1

1	+	2	+	3	+	4	+	1	+	2	+	3	+	4	+
	X	X	X			X	X	X			X	X	X		

5 5 6

Here's the same pattern with voicing that emphasizes the last note in each figure:

PATTERN 25-2

1	+	2	+	3	+	4	+	1	+	2	+	3	+	4	+
	O	O	X			O	O	X			O	O	X		

Here's the pattern again with different voicing:

PATTERN 25-3

1	+	2	+	3	+	4	+	1	+	2	+	3	+	4	+
	X	X	X			X	X	X			O	O	O		

THREE NOT-QUITE-EQUAL GROUPS OF BEATS IN FOUR 129

Here's a 5/6/5 pattern that starts on 2. This puts the last note of the last figure on the last beat of the cycle. We've emphasized the suspended effect of ending on the beat before ONE by putting the last figure in the alternate voice:

PATTERN 25-4

1	+	2	+	3	+	4	+	1	+	2	+	3	+	4	+
		X	X	X			X	X	X				O	O	O

The figures in all the following patterns are positioned so the patterns end on ONE:

PATTERN 25-5

1	+	2	+	3	+	4	+	1	+	2	+	3	+	4	+
O			X̲	X	X			X	X	X				O	O

PATTERN 25-6

1	+	2	+	3	+	4	+	1	+	2	+	3	+	4	+
O		X̲	X	O	O			X	X	O	O		X	X	O

PATTERN 25-7

1	+	2	+	3	+	4	+	1	+	2	+	3	+	4	+
O		X̲		O	O			X		O	O		X		O

In the next chart, we've taken the last pattern and used it as the basis
for a longer pattern:

PATTERN 25-8

1	+	2	+	3	+	4	+	1	+	2	+	3	+	4	+
		X		O	O			X		O	O		X		O
O										X		O	O		
		X		O	O			X		O	O		X		O
O										X		O	O		
		X		O	O			X		O	O		X		O
O		X		O	O			X		O	O		X		O
O		X		O	O			X		O	O		X		O
O										X		O	O		

It's your turn again. Make up your own figures, rearrange them,
change the voicing, shift the pattern. You can see we've covered only
a few of the countless patterns you can create using three not-quite-
equal groups of beats in four.

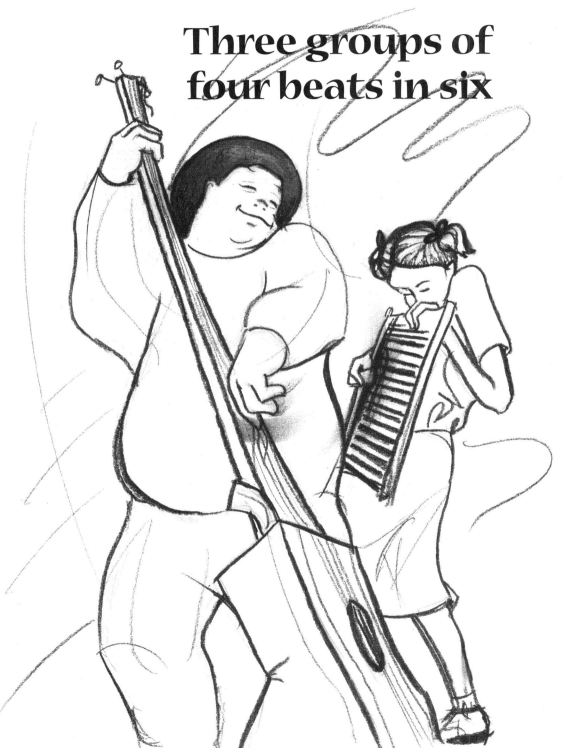

CHAPTER **10**

Three groups of four beats in six

lesson **26**

The 3-pulse and 3 over 4

In six – unlike four – it *is* possible to divide the cycle into three equal groups of beats.

That's what the **3-pulse** does. It divides the 12 beats of the cycle into three equal groups of four beats:

1	2	3	4	5	6	1	2	3	4	5	6

The 3-pulse is common in African and Afro-Cuban rhythms. If you think of it as creating 3/4 time, the 12-beat cycle is a single measure long and each subdivision is a sixteenth note:

1	e	+	a	2	e	+	a	3	e	+	a

To get the feel of the 3-pulse, start by tapping it in your feet while you count. If you alternate feet, notice they take turns tapping ONE:

PATTERN 26-1

In the next chart, you can see the relationship between the 3-pulse (shaded on the count row) and the timeline (on the bottom row). Notice that the pulses on 1 and 5 in the first measure coincide with notes in the timeline, but the pulse on 3 in the second measure comes in between notes in the timeline.

Now tap the 3-pulse in your feet while you clap or play the timeline. You'll notice that the timeline feels different even when you play all the notes at the same volume:

PATTERN 26-2

1	2	3	4	5	6	1	2	3	4	5	6
X		X		X	X		X		X		X

In the next exercise, listen to the timeline on the CD while you alternate tapping the 3-pulse and the 4-pulse in your feet. Stay with each one until you feel like switching. Notice how changing the pulse changes your perception of the timeline (which we've shaded on the count row):

PATTERN 26-3

1	2	3	4	5	6	1	2	3	4	5	6
𝔂			𝔂			𝔂			𝔂		
𝔂		𝔂		𝔂		𝔂		𝔂			

The 3-pulse and 4-pulse are uneven with each other because neither contains all the notes of the other. Switching from one pulse to another pulse that's uneven with it while keeping the subdivisions the same length is called **metric modulation**. In the next exercise, you're going to do metric modulations by switching from tapping a 3-pulse to

a 4-pulse to a 6-pulse and back to a 4-pulse again. Stay with each pulse until you feel like switching:

PATTERN 26-4

1	2	3	4	5	6	1	2	3	4	5	6
👣			👣			👣					
👣		👣		👣		👣					
👣		👣	👣	👣		👣		👣		👣	
👣			👣			👣			👣		

For a real workout, when you get comfortable switching back and forth, turn off the CD and clap the timeline while switching pulses in your feet.

You can experiment with a 3-pulse in your feet with any pattern in six. But for consistency – and because it's more common – we're going to stick with an underlying 4-pulse.

Now you're going to put the 4-pulse back in your feet and play the 3-pulse *over* it. This creates the polyrhythm of 3 over 4 and takes you *out* of the realm of 3/4 time, which has an underlying 3-pulse. Once the "3-pulse" is no longer the underlying pulse, it isn't technically a "pulse" at all. But since its pattern of evenly-spaced notes continues to imply a 3-pulse, we'll continue to refer to it as the "3-pulse" or the "3-pulse pattern."

Notice the relationship between the two pulses in the next chart. They start *together*. The second note in the 3-pulse comes just *after* the second 4-pulse. And the third note in the 3-pulse comes just *before* the fourth 4-pulse. You may find it easier to play and remember 3 over 4 if you focus on this "together-after-before" aspect of the relationship:

PATTERN 26-5

1	2	3	4	5	6	1	2	3	4	5	6
X				X				X			

You may also find it helpful to play the composite pattern of 3 over 4:

PATTERN 26-6

1	2	3	4	5	6	1	2	3	4	5	6
X			X	X		X		X	X		

Remember, when we talk about a polyrhythm like 3 over 4, we're talking about two patterns perceived simultaneously that divide the same span of time differently. Here the span of time is the 12-beat cycle. The expression "3 over 4" refers to 3 evenly-spaced notes played over 4 evenly-spaced pulses in the same span of time. Sometimes these numbers can be confusing, because if you switch your focus from the number of *notes* in each *pattern* to the number of *beats* in each *group*, the numbers get reversed: the 3-pulse creates 3 groups of 4 beats and the 4-pulse creates 4 groups of 3:

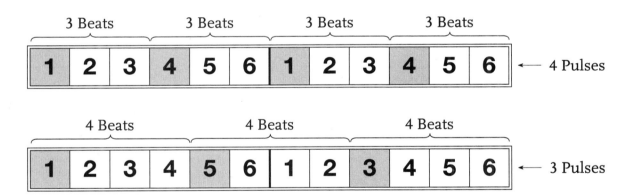

For the rest of this chapter, you'll be playing a variety of patterns based on a 3-pulse on your instrument *over* a 4-pulse in your feet. Because the patterns are based on a pulse that's uneven with the underlying 4-pulse, they tend to obscure the underlying pulse to varying degrees. So before you move on, make sure you really understand the polyrhythm of pattern 26-5. It will make the next four lessons a lot easier.

Set 1

Here's the polyrhythm from the last lesson – the 3-pulse pattern over the underlying 4-pulse:

PATTERN 27-1

1	2	3	4	5	6	1	2	3	4	5	6
X				X				X			

Notice again that the 3-pulse pattern creates three groups of four beats. We call this set of groups "set 1."

In the next pattern, we've filled the space between each of the 3-pulses in set 1 with the alternate voice. This creates 3 four-note figures. Put the 4-pulse in your feet, but don't turn on the timeline until you can play this polyrhythm comfortably without having to count it:

PATTERN 27-2

1	2	3	4	5	6	1	2	3	4	5	6
X	O	O	O	X	O	O	O	X	O	O	O

In the next pattern we've changed the voicing so each group of four notes consists of two pairs:

PATTERN 27-3

1	2	3	4	5	6	1	2	3	4	5	6
X	X	O	O	X	X	O	O	X	X	O	O

If you focus too much on this pattern while you play it, the 3-pulse it implies is likely to overtake the underlying 4-pulse. You'll know it's happening when you start feeling like your feet belong to someone else.

Now switch to using a single voice and create space by leaving out the fourth note in every group of four. This creates a pattern often called the abakwa pattern in Afro-Cuban rhythms:

PATTERN 27-4A

1	2	3	4	5	6	1	2	3	4	5	6
X	X	X		X	X	X		X	X	X	

Notice that these figures aren't parallel because each has a different relationship to the 4-pulse. A pulse falls at the beginning of the first figure, at the end of the second, and in the middle of the third. Learning this pattern may be easier if you remember the relationship of each figure to the pulse that falls within it – "beginning-end-middle":

PATTERN 27-4B

1	2	3	4	5	6	1	2	3	4	5	6
X	X	X		X	X	X		X	X	X	

When you play this pattern with the timeline in six you may want to add ghost notes until your ear learns the sound of the two patterns together:

PATTERN 27-4C

1	2	3	4	5	6	1	2	3	4	5	6
X	X	X	•	X	X	X	•	X	X	X	•

Another way to really get to know the relationship between this pattern and the timeline is to tap it in one hand while you tap the timeline in the other. This is hard, so go slow and expect this exercise to take some time. To keep the two patterns distinct, make a different sound with each hand.

You can dilute the 3-pulse implied by these figures by changing the voicing. Generally the use of anything other than a single voice will greatly weaken the implication of a 3-pulse and may even make it disappear. For example, notice whether you still feel any hint of the 3-pulse in the next pattern. We've voiced the figures to activate the tendency to group notes in the same voice together, so it may quickly feel like pattern starts on 3 in the second measure and overlaps ONE:

PATTERN 27-5

1	2	3	4	5	6	1	2	3	4	5	6
O	O	O		X	X	X		O	O	O	

The only time a second voice actually strengthens the 3-pulse in these figures is when the second voice is used exclusively on the notes of the 3-pulse itself:

PATTERN 27-6

1	2	3	4	5	6	1	2	3	4	5	6
X	O	O		X	O	O		X	O	O	

Because these figures – as well as the same figures in a single voice – tend to obscure the pulse, when you improvise in six over a 4-pulse you may want to use them sparingly. In the next chart, we've diluted their pulse-obscuring effect by switching on alternating cycles to pairs that reinforce the 4-pulse:

PATTERN 27-7

1	2	3	4	5	6	1	2	3	4	5	6
X	O	O		X	O	O		X	O	O	
X	O	O			O	O			O		O

Another way to dilute the pulse-obscuring effect of these figures is to create some space in the pattern. We've used the single-voice figures in the next chart and taken out the middle note in the third figure:

PATTERN 27-8

1	2	3	4	5	6	1	2	3	4	5	6
X	X	X		X	X	X		X		X	

Now there's a string of three odd-numbered beats in the second measure. So the pattern starts out looking like it's going to imply a 3-pulse and then abruptly switches in the second measure to implying a 6-pulse. As a result, neither alternative pulse is implied strongly enough to challenge the underlying 4-pulse.

lesson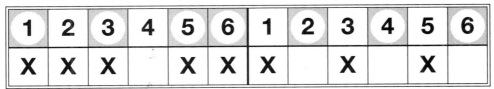

Set 2

When you shift the 3-pulse over a beat, the pulses fall on beats 2 and 6 in the first measure and 4 in the second:

PATTERN 28-1A

1	2	3	4	5	6	1	2	3	4	5	6
	X				X				X		

In this lesson, you'll create patterns based on this shifted 3-pulse pattern. Notice that the note on 4 in the second measure coincides with the last 4-pulse. Also notice that the relationship of this 3-pulse pattern to the 4-pulse is: "after-before-together."

Here's the new pattern with the timeline on the count row. Notice they coincide on 6 in the first measure and 4 in the second:

PATTERN 28-1B

1	2	3	4	5	6	1	2	3	4	5	6
	X				X				X		

This shifted 3-pulse pattern creates a different set of three groups of four beats we call "set 2." To make the groups stand out, we've filled the space between each note of the shifted 3-pulse pattern with the alternate voice:

PATTERN 28-2

1	2	3	4	5	6	1	2	3	4	5	6
O	X̲	O	O	O	X	O	O	O	X	O	O

Now change the voicing so that each four-note group contains two pairs:

PATTERN 28-3

1	2	3	4	5	6	1	2	3	4	5	6
O	X̲	X	O	O	X	X	O	O	X	X	O

In the next chart you arrive at this same pattern by compressing two parallel figures. Notice that the pattern ends with a stabilizing note on ONE before the implied 3-pulse has a chance to get firmly established:

PATTERN 28-4

1	2	3	4	5	6	1	2	3	4	5	6
	X	X	O	O			X	X	O	O	
	X	X	O	O	X	X	O	O	X	X	O
O											

Now play the three-note figures of set 2:

PATTERN 28-5

1	2	3	4	5	6	1	2	3	4	5	6
	X	X	X		X	X	X		X	X	X

The 3-pulse implied by these figures is weaker than the 3-pulse implied by the same figures of set 1, mainly because the pattern doesn't start on ONE. But you can strengthen the implied 3-pulse by accenting it with voicing:

PATTERN 28-6

1	2	3	4	5	6	1	2	3	4	5	6
	X	O	O		X	O	O		X	O	O

Now create space in this pattern by taking out the second two notes in the last figure:

PATTERN 28-7

1	2	3	4	5	6	1	2	3	4	5	6
	X	O	O		X	O	O		X		

Now combine variations:

PATTERN 28-8

1	2	3	4	5	6	1	2	3	4	5	6
	X	O	O		X	O	O		X		
	X	O	O		X	O	O		X		
	X	O	O		X	O	O		X	O	O
	X	O	O		X	O	O		X		

Now create even more space in the pattern by taking out the second two notes in the first figure too:

PATTERN 28-9

1	2	3	4	5	6	1	2	3	4	5	6
	X			X	O	O			X		

Now go back to the three-note figures of set 1 and see what happens when you create space in those figures in the same way.

lesson **29**

Set 3

Shifting the 3-pulse another beat to the right creates three new groups of four beats we call "set 3." The notes of the 3-pulse pattern now fall on beat 3 in the first measure and beats 1 and 5 in the second:

PATTERN 29-1A

1	2	3	4	5	6	1	2	3	4	5	6
		X				X				X	

Notice that the relationship of this shifted 3-pulse pattern to the 4-pulse is "before-together-after."

Here's the new pattern with the timeline on the count row. Notice the two patterns coincide only on 3 in the first measure:

PATTERN 29-1B

1	2	3	4	5	6	1	2	3	4	5	6
		X				X				X	

Now fill the space with the alternate voice so there are four notes in each group:

PATTERN 29-2

1	2	3	4	5	6	1	2	3	4	5	6
O	O	<u>X</u>	O	O	O	X	O	O	O	X	O

When you take the fourth note out of each group and create the three-note figures of set 3, the pattern ends on ONE:

PATTERN 29-3

1	2	3	4	5	6	1	2	3	4	5	6
X		<u>X</u>	X	X		X	X	X		X	X

You can emphasize that note on ONE by playing it with a technique drummers call a **flam**. A flam is produced by playing two notes almost simultaneously, one on the beat and one just before it. When both notes in a flam are played with the same sound, they sound like a single note with a thick texture. If you can't play two notes with the same sound on your instrument, play another note just before the beat like a grace note. A small "x" above and to the left of a large "X" indicates a flam on our charts:

PATTERN 29-4

1	2	3	4	5	6	1	2	3	4	5	6
		X	X	X		X	X	X		X	X
ˣX											

You can *accent with a flam* by substituting it for any note you want to emphasize.

VARIATION
TECHNIQUE

Accent with a flam

Now combine variations to create a longer pattern:

PATTERN 29-5

1	2	3	4	5	6	1	2	3	4	5	6
		X	X	X		X	X	X		X	X
ˣX					O	O	O		O		
		X	X	X		X	X	X		X	X
ˣX					O	O	O		O		
		X	X	X		X	X	X		X	X
ˣX		X	X	X		X	X	X		X	X
ˣX		X	X	X		X	X	X		X	X
ˣX					O	O	O		O		

If you change the voicing to accent the third note in each figure, you can use these set 3 figures to imply the 3-pulse from set 1:

PATTERN 29-6

1	2	3	4	5	6	1	2	3	4	5	6
X		O	O	X		O	O	X		O	O

You're going to use the same voicing for the figures in the next chart, where you start with two parallel three-note figures in the first cycle and then compress them:

PATTERN 29-7

1	2	3	4	5	6	1	2	3	4	5	6
		O	O	X				O	O	X	
		O	O	X		O	O	X		O	O
ˣX											

Now take the compression a step further, until there's no space between the figures:

PATTERN 29-8

1	2	3	4	5	6	1	2	3	4	5	6
		O	O	X				O	O	X	
		O	O	X		O	O	X		O	O
X	O	O	X	O	O	X	O	O	X	O	O
ˣX											

A series of compressions can sound like a car being started on a cold morning. The engine turns over slowly at first, but revs up when you step on the gas.

Set 4

Shifting the 3-pulse over another beat creates set 4. The notes of the 3-pulse pattern now fall on beat 4 in the first measure and beats 2 and 6 in the second. The relationship of this 3-pulse pattern to the underlying 4-pulse is "together-after-before":

PATTERN 30-1A

1	2	3	4	5	6	1	2	3	4	5	6
			X				X				X

Here's this 3-pulse pattern with the timeline on the count row. The two patterns coincide on 2 and 6 in the second measure:

PATTERN 30-1B

1	2	3	4	5	6	1	2	3	4	5	6
			X				X				X

Set 4 is the last set of three groups of four beats. If you shift the 3-pulse again, so it starts on beat 5, you're back to set 1 starting on a different beat.

Here are the three-note figures of set 4. We start the pattern on 6 in the second measure because it's closest to ONE. Use the reference point on that beat in the timeline to find your starting point and put in ghost notes if you need to:

PATTERN 30-2

1	2	3	4	5	6	1	2	3	4	5	6
X	X		X	X	X		X	X	X		<u>X</u>

This pattern and the timeline are similar in structure, so it's easy to alternate playing the two patterns:

PATTERN 30-3

1	2	3	4	5	6	1	2	3	4	5	6
X		X		X	X		X		X		X
X	X		X	X	X		X	X	X		X

In the next chart, we add a cycle of pairs reinforcing the underlying 4-pulse between the timeline and the three-note figures of set 4:

PATTERN 30-4

1	2	3	4	5	6	1	2	3	4	5	6
X		X		X	X		X		X		X
X		X	X		X	X		X	X		X
X	X		X	X	X		X	X	X		X
O	O		X	O	O		X	O	O		X
O	O		X	O	O		X	O	O		X

As you can tell from this pattern, playing figures implying a 3-pulse for three full cycles *and* emphasizing the 3-pulse with voicing makes it very tough to hold on to the underlying 4-pulse.

Now start and end the three-note figures on beat 4 in the first measure using voicing that emphasizes the shifted 3-pulse:

PATTERN 30-5

1	2	3	4	5	6	1	2	3	4	5	6
			X	O	O		X	O	O		X
O	O		ˣX								

We're going to use this pattern to introduce the technique of *isolating and repeating* a part of a pattern. Start by playing the full pattern twice. Then isolate and repeat just the first row, which creates the suspended effect of ending on the beat before ONE. Then play the full pattern again to conclude the sequence:

PATTERN 30-6

1	2	3	4	5	6	1	2	3	4	5	6
			X	O	O		X	O	O		X
O	O		ˣX								
			X	O	O		X	O	O		X
O	O		ˣX								
			X	O	O		X	O	O		X
			X	O	O		X	O	O		X
			X	O	O		X	O	O		X
O	O		ˣX								

Now practice the technique of isolating and repeating part of a pattern on your own using any patterns you like.

In addition to playing three-note figures based on a 3-pulse, you can also play pairs. Here are the pairs of set 4:

PATTERN 30-7

1	2	3	4	5	6	1	2	3	4	5	6
X			X	X			X	X			X̲

After you're comfortable with these pairs, go back and experiment with the pairs of sets 1, 2, and 3.

Now you're going to use the technique of *expanding* a pattern, which is simply the opposite of compressing it. When you **expand** a pattern, you add space between or within repeating figures so fewer of them fit within a cycle. The next pattern starts with pairs that reinforce the 4-pulse. By adding space between the pairs in the second cycle, you expand the pattern and end up with the pairs of set 4 (which you in turn compress when you repeat the pattern):

PATTERN 30-8

1	2	3	4	5	6	1	2	3	4	5	6
X		X	X		X	X		X	X		X
X			X	X			X	X			X̲

Here's the timeline pattern expanded to twice its length:

PATTERN 30-9

1	2	3	4	5	6	1	2	3	4	5	6
X				X				X		X	
		X				X				X	

In one of his instructional videos, the conga drummer Giovanni Hidalgo plays this expanded timeline in one hand while playing the normal timeline in the other. You may want to try this yourself. But you have to play the combination really fast before the expanded timeline becomes recognizable.

Cross-rhythms

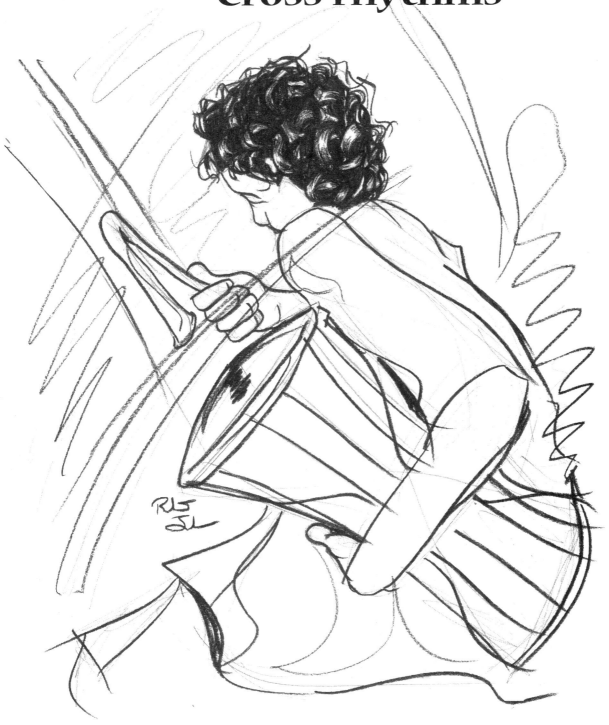

3-beat cross-rhythms in four

A cross-rhythm is a repeating figure played for longer than a cycle of the timeline that has an **uneven cycle** in relation to the cycle of the timeline (or whatever part defines the underlying cycle of a rhythm). Two cycles are uneven when you can't evenly divide the number of beats in the longer cycle by the number in the shorter.

Let's bring this definition down to earth with an example. The next chart contains a simple repeating figure with a 3-beat cycle. Remember that the cycle of a repeating pattern is the number of beats from the start of one repetition to the start of the next. So the empty beat after each figure counts as one of the 3 beats in each cycle:

PATTERN 31-1

1	+	2	+	3	+	4	+	1	+	2	+	3	+	4	+
X	X		X	X		X	X		X	X		X	X		X
X		X	X		X	X		X	X		X	X		X	X
	X	X		X	X		X	X		X	X		X	X	

Because the figure is repeated for more than a cycle of the timeline, and because the number of beats in the longer cycle of the timeline (16) can't be evenly divided by the number of beats in the shorter cycle of the figure (3), this pattern is a cross-rhythm.

Notice that the figures in pattern 31-1 alternate between starting on numbered beats and offbeats, and that the starting points cycle through each subdivision in turn: pulse, offbeat before the pulse, upbeat, offbeat after the pulse, etc. This shifting of starting points in relation to the pulse gives cross-rhythms their vitality, but it also makes them challenging to play.

It's also challenging to remember the long patterns cross-rhythms create. Notice that the figure in pattern 31-1 starts with the timeline on ONE but that it takes three cycles of the timeline before it starts together with the timeline on ONE again. The **compound cycle** – the

number of beats it takes the combination of the two patterns to repeat – is 48 beats long (16 times 3).

But you won't usually want to play the full compound cycle of a cross-rhythm. Cross-rhythms – like all patterns that obscure the underlying pulse and create a lot of rhythmic tension – usually work best in small doses. Playing a full compound cycle will often confuse your audience and try the patience of the musicians you're playing with. Think of a compound cycle as a database. Once you have it in your vocabulary, you can decide how much of it to play.

One way to use a compound cycle to generate ideas is to pick any row and play it as a repeating pattern. This is also a good way to learn the compound cycle in stages. For example, here's the third row from the compound cycle as a repeating pattern on its own chart:

PATTERN 31-2

1	+	2	+	3	+	4	+	1	+	2	+	3	+	4	+
	X	X		X	X		X	X		X	X		X	X	

This row works well just as it is. But often you'll want to change a row in one way or another. Here's the first row from the compound cycle rounded off at the end so it flows more smoothly when repeated:

PATTERN 31-3

1	+	2	+	3	+	4	+	1	+	2	+	3	+	4	+
X	X		X	X		X	X		X	X		X		X	

Here's another section taken from the compound cycle:

PATTERN 31-4

1	+	2	+	3	+	4	+	1	+	2	+	3	+	4	+
X		X	X		X	X						X	X		X

If you play the full first row of the compound cycle, you can end the pattern on ONE of the second cycle of the timeline. Then you'll have some empty space to play with before the pattern starts over:

PATTERN 31-5

1	+	2	+	**3**	+	4	+	**1**	+	2	+	**3**	+	4	+
X	X		X	X		X	X		X	X		X	X		X
X							oo	O	O	O	O	X	X		

In the next chart, we create a longer pattern by repeating the pattern you just played twice and then finishing with the full cross-rhythm. Playing parts of the cross-rhythm and then playing the full pattern feels a little like taking a few test runs at a steep hill before finally working up enough momentum to make it all the way over the top. Notice the timeline is shaded on the count row:

PATTERN 31-6

1	+	2	**+**	3	+	**4**	+	1	+	**2**	+	**3**	+	4	+
X	X		X	X		X	X		X	X		X	X		X
X							oo	O	O	O	O	X	X		
X	X		X	X		X	X		X	X		X	X		X
X							oo	O	O	O	O	X	X		
X	X		X	X		X	X		X	X		X	X		X
X		X	X		X	X		X	X		X	X		X	X
	X	X		X	X		X	X		X	X		X	X	
X							oo	O	O	O	O	X	X		

Now create a sparse 3-beat cross-rhythm by playing just a single note every 3 beats. We've charted the full compound cycle, but remember that in most playing situations you'll only want to use part of it:

PATTERN 31-7

1	+	2	+	3	+	4	+	1	+	2	+	3	+	4	+
X			X			X		X			X			X	
		X			X			X			X			X	
	X			X			X			X			X		

1	+	2	+	3	+	4	+	1	+	2	+	3	+	4	+
X			X			X			X			X			X
		X			X			X			X			X	
	X			X			X			X			X		

Notice that this pattern not only forms a cross-rhythm with the time-line, it also forms a polyrhythm with the pulse. It has 4 evenly-spaced notes over 3 evenly-space pulses in the same span of time:

PATTERN 31-8

In fact, *all* 3-beat cross-rhythms in four create polyrhythms because they imply a pulse every 3 beats that's uneven with the underlying pulse every 4 beats.

lesson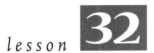

6-beat cross-rhythms in four

A repeating figure with a 6-beat cycle can create a cross-rhythm in four because you can't evenly divide 16 (the number of beats in the longer cycle of the timeline) by 6. And the compound cycle will be 48 beats long (three times through the timeline) just as it is with a 3-beat cross-rhythm. But instead of cycling the figures through all subdi-

visions, 6-beat cross-rhythms in four either shift the figures between pulses and upbeats or between offbeats before and after the pulse.

Here's the compound cycle of a common 6-beat cross-rhythm that shifts the figures back and forth between pulses and upbeats:

PATTERN 32-1

1	+	2	+	3	+	4	+	1	+	2	+	3	+	4	+
X		O	O			X		O	O			X		O	O
		X		O	O			X		O	O			X	
O	O			X		O	O					X		O	O

We bring in a section of this cross-rhythm in the next chart after starting with a similar pattern consisting of parallel figures. You can think of the figures in the cross-rhythm as isolating and repeating the last three notes of the parallel figures (notice that you start on the last note of the chart):

PATTERN 32-2

1	+	2	+	3	+	4	+	1	+	2	+	3	+	4	+
X		O	O			X		X		O	O			X	
X		O	O			X		O	O			X		O	O
		X		O	O			X		O	O			X	

Whenever you start a 6-beat cross-rhythm on a numbered beat, each figure in the compound cycle will start on a numbered beat. If you want the figures to start on offbeats, just shift the whole pattern over a beat:

PATTERN 32-3

1	+	2	+	3	+	4	+	1	+	2	+	3	+	4	+
	X		O	O			X		O	O			X		O
O			X		O	O			X		O	O			X
	O	O			X		O	O			X		O	O	

Notice the figures now shift back and forth between the offbeats after and before the pulse.

When you create these two compound cycles with a 6-beat cross-rhythm – one with the figures starting on numbered beats and one with the figures starting on offbeats – you generate all possible shifted versions of the repeating figure. Then, no matter what beat you want to start on, you'll be able to find a figure that starts on that beat somewhere in the two compound cycles.

In the next pattern, voicing turns the numbered beats into a 6-beat cross-rhythm:

PATTERN 32-4

1	+	2	+	3	+	4	+	1	+	2	+	3	+	4	+
O		O		X		O		O		X		O		O	
X		O		O		X		O		O		X		O	
O		X		O		O		X		O		O		X	

Although you'll rarely hear the full compound cycle of this cross-rhythm, you'll hear sections of it in a lot of conga solos. In the next chart, the first row is the cascara pattern we introduced on page 69 and the second row is the first row from the compound cycle of the cross-rhythm:

PATTERN 32-5

1	+	2	+	3	+	4	+	1	+	2	+	3	+	4	+
X		X	X		X		X	X		X		X	X		X
O		O		X		O		O		X		O		O	

Shifting this cross-rhythm over a beat transforms the *offbeats* into a 6-beat cross-rhythm:

PATTERN 32-6

1	+	2	+	3	+	4	+	1	+	2	+	3	+	4	+
	O		O		X		O		O		X		O		O
	X		O		O		X		O		O		X		O
	O		X		O		O		X		O		O		X

Now take the first row from this compound cycle and add a note to end the pattern on ONE:

PATTERN 32-7

1	+	2	+	3	+	4	+	1	+	2	+	3	+	4	+
	O		O		X		O		O		X		O		O
X															

The next 6-beat cross-rhythm uses five-note figures. If you start on ONE and play three figures, the last note of the last figure will fall on ONE in the next cycle of the timeline:

PATTERN 32-8

1	+	2	+	3	+	4	+	1	+	2	+	3	+	4	+
O	O	O	O	X		O	O	O	O	X		O	O	O	O
X															

In the next chart, we've gone right from the cross-rhythm into a straight pattern in four:

PATTERN 32-9

1	+	2	+	3	+	4	+	1	+	2	+	3	+	4	+
O	O	O	O	X		O	O	O	O	X		O	O	O	O
X		X	X		X	X		O		O	O		O	O	

Now vary the figures of the cross-rhythm by substituting two sixteenth notes for the first eighth note and changing the voicing of the next to last note:

PATTERN 32-10

1	+	2	+	3	+	4	+	1	+	2	+	3	+	4	+
oo	O	O	X	X		oo	O	O	X	X		oo	O	O	X
X		X	X		X	X		O		O	O		O	O	

In the next chart, we bring in this same 6-beat cross-rhythm on the last beat of the fourth row. Notice that the structure of the figures in the cross-rhythm is similar to the structure of the longer parallel

figures that come before them, creating the illusion that the original pattern has been compressed:

PATTERN 32-11

1	+	2	+	3	+	4	+	1	+	2	+	3	+	4	+
							oo	O	O	O	O	X	X		
							oo	O	O	O	O	X	X		
							oo	O	O	O	O	X	X		oo
O	O	O	O	X	X		oo	O	O	O	O	X	X		oo
O	O	X	X		oo	O	O	X	X		oo	O	O	X	X
	oo	O	O	X	X		oo	O	O	O	O	O	O	X	X

Now it's your turn. Pick out whichever of these cross-rhythms you like best and work them into your own improvisations. Then make up your own 6-beat figures and do the same. If it helps, write the patterns down. When you find a pattern you really want to make a part of you, take it for a rhythm walk. You can get a lot of mileage out of a single cross-rhythm.

lesson **33**

8-beat cross-rhythms in six

To create cross-rhythms in six you need to play figures with cycles that are uneven with the 12-beat cycle of the timeline. Figures with 3-beat or 6-beat cycles won't work the way they did in four because 12 is evenly divisible by 3 and 6. And the figures with 4-beat cycles (based on a 3-pulse) you played in the last chapter won't technically create cross-rhythms either (even though they do sound like them), because 12 is also evenly divisible by 4.

But 12 is *not* evenly divisible by 8, so let's start there to create cross-rhythms in six. Here's an 8-beat cross-rhythm using a figure you've already played in four. Playing patterns like this at the triple-weave level is challenging, but it's worth the effort to experience the beautiful songs they make with the pulse and the timeline:

PATTERN 33-1

1	2	3	4	5	6	1	2	3	4	5	6
X	X	O	O	X	X			X	X	O	O
X	X			X	X	O	O	X	X		

Notice that each figure starts in a different spot in relation to the pulse. The first figure starts on the pulse, the second on the offbeat before the pulse, and the third on the offbeat after the pulse. Any 8-beat cross-rhythm in six will cycle the figures through each subdivision in turn.

Also notice that the compound cycle of an 8-beat cross-rhythm and the timeline in six is only 24 beats, just twice through the timeline. That means the figures repeat only three times before the compound cycle starts over. To hear all the variations of an 8-beat cross-rhythm, you need to shift it seven times. Here's the song you get when you start the pattern on 2:

PATTERN 33-2

1	2	3	4	5	6	1	2	3	4	5	6
	X	X	O	O	X	X			X	X	O
O	X	X			X	X	O	O	X	X	

Playing a cross-rhythm like this at the triple-weave level requires the kind of intense concentration that can easily lead to a state of trance. In the next chart, the single-cycle pattern repeated in the first two rows will prevent the cross-rhythm in the second two rows from taking you too far off-center:

PATTERN 33-3

1	2	3	4	5	6	1	2	3	4	5	6
	X	X	O	O	X	X			X	X	
	X	X	O	O	X	X			X	X	
	X	X	O	O	X	X			X	X	O
O	X	X			X	X	O	O	X	X	

Here's an 8-beat cross rhythm consisting of seven-note figures:

PATTERN 33-4

1	2	3	4	5	6	1	2	3	4	5	6
O	O	O	O	O	O	X		O	O	O	O
O	O	X		O	O	O	O	O	O	X	

You may have noticed that the less space there is between figures, the easier a cross-rhythm is to play. That's because the steady motion in your hands keeps you from losing your place. There's nothing wrong with feeling your way through a pattern even if you can't hear the song yet. Sometimes your hands can teach your ears.

In the next pattern, we use voicing to turn the even-numbered beats into an 8-beat cross-rhythm. It really herks and jerks against the pulse.

The timeline gives you lots of reference points, so we've shaded it on the count row:

PATTERN 33-5

1	2	3	4	5	6	1	2	3	4	5	6
	X		X		O	O			X		X
	O		O		X	X			O		O

The next 8-beat cross-rhythm is another familiar pattern you've played in four. To make it easier to play in six, we've switched from a 4-pulse to a 3-pulse. This pattern only gets interesting at the triple-weave level, so turn on the timeline, get your feet going on the 3-pulse, and then play the pattern:

PATTERN 33-6A

1	2	3	4	5	6	1	2	3	4	5	6
X			X	X		O	O	X			X
X		O	O	X			X	X		O	O

Did the timeline sound different? If it did, here's what happened. You started feeling the three figures as a pattern in four instead of as a cross-rhythm in six. (And that's perfectly natural since the 8-beat cycle of each figure is exactly the same length as a measure in four, and the 3-pulse in six falls on every fourth beat just like the pulse in four does.) Once you start feeling the figures as a pattern in four, you start hearing two repetitions of the timeline as a single three-measure pattern in four. Here's what that looks like:

PATTERN 33-6B

Whenever your perception of a timeline shifts, you get a new framework for improvisation that's bound to inspire new ideas in your playing. To help you develop the ability to consciously shift your perception of the timeline in six, turn off the CD and practice playing two repetitions of it as a three-measure pattern in four. We've broken the pattern into three one-measure sections so you can master it a piece at a time. When you've done that, put the whole thing together:

PATTERN 33-7

1	+	2	+	3	+	4	+
X		X		X	X		X

1	+	2	+	3	+	4	+
	X		X	X		X	

1	+	2	+	3	+	4	+
X	X		X		X		X

Once you can comfortably play the timeline in six as a three-measure pattern in four, you'll be able to easily shift to *hearing* it in four. And once you can do that, playing 8-beat cross-rhythms in six will be a breeze.

5-beat and 7-beat cross-rhythms

Figures with 5-beat cycles can create cross-rhythms in both four and six because you can't evenly divide either 16 or 12 by 5. The compound cycle of the timeline and a 5-beat cross-rhythm in both four and six will be five repetitions of the timeline. And in both four and six, a 5-beat cross-rhythm will cycle the starting points of the figures through each subdivision in turn.

Start in four. You already played 5-beat cycle figures ("5's" for short) when you played 5/5/6 patterns in lessons 24 and 25. To create a cross-rhythm, all you have to do is play more 5's.

The next chart has the full compound cycle of a simple 5. Although it's a great long song, you should mainly think of this chart as a database you can draw upon rather than as a pattern to play. Notice that the figures alternate between numbered beats and offbeats:

PATTERN 34-1

1	+	2	+	3	+	4	+	1	+	2	+	3	+	4	+
X			O	O		X			O	O		X			X
		O	O		X			O	O		X			X	
O	O		X			O	O		X			X			O
O		X			O	O		X			X			O	O
	X			O	O		X			X			O	O	

We especially like two rows of this compound cycle: the last followed by the first. In the next chart, we spend a few cycles creating a context

before going into the cross-rhythm. We've also substituted a flam for the first note in each figure to spice things up:

PATTERN 34-2

1	+	2	+	3	+	4	+	1	+	2	+	3	+	4	+
ˣX		O	O	ˣX		O	O	ˣX		O	O				
ˣX		O	O	ˣX		O	O	ˣX		O	O				
ˣX		O	O	ˣX		O	O	ˣX		O	O				ˣX
	O	O		ˣX		O	O	ˣX		O	O		ˣX		
ˣX															

Now switch to six and play the same 5-beat cross-rhythm you just played in four. The compound cycle here is unusually fruitful. Every row makes a good repeating pattern all by itself:

PATTERN 34-3

1	2	3	4	5	6	1	2	3	4	5	6
X		O	O		X		O	O		X	
O	O		X		O	O		X		O	O
	X		O	O		X		O	O		X
	O	O		X		O	O		X		O
O		X		O	O		X		O	O	

If you want to play the full compound cycle straight through, it may help to notice the sequence in the numbers of the beats the figures start on. The first figure starts on 1, the next on 6, the next on 5, the next on 4, and so on in descending order until the seventh figure starts on 1 again and the sequence repeats.

Next we work some of these 5's into a longer pattern. Repeat any row or set of rows as many times as you like:

PATTERN 34-4

1	2	3	4	5	6	1	2	3	4	5	6
X			X	O	O	X			X	O	O
X			X	O	O	X			X	O	O
X		O	O	X		O	O	X		O	O
X		O	O	X		O	O	X		O	O
X		O	O		X		O	O	X		
O	O		X		O	O		X		O	O
X		O	O		X		O	O	X		
O	O		X		O	O		X		O	O
X		O	O		X		O	O	X		
X		O	O		X		O	O	X		
O	O		X		O	O		X		O	O
ˣX											

ow that you have charts of the compound cycles created by 5-beat cross-rhythms in four and six, you can plug in different figures and experiment. Here are a few to get you started:

X	X			
X	X	X		
X		X	X	
X	X	O	O	
O	O	X	X	
oo	O	X	X	
oo	oo	X	X	
X	O	O	X	
X	X	X	X	
xx	X	O	O	

The last cross-rhythms we're going to cover are 7-beat cross-rhythms. We're not going to spend a lot of time on them, partly because they're less common than the others we've covered and partly because you know enough now to be able to generate 7's on your own. But we will make a few points to get you started.

In both four and six, 7-beat cross-rhythms cycle the starting points of the figures through each subdivision in turn. But the sequence of starting points has a different numerical pattern in both four and six.

In four, a 7-beat cross-rhythm has one less beat than the 8-beat measure. So if a pattern of 7's starts on 1, the second figure will start on the AND of 4, the next on 4, the next on the AND of 3, and so on in descending order. You can see the start of this sequence in the next chart, where we run 7's for two measures before cutting the pattern short and letting it repeat:

PATTERN 34-5

1	+	2	+	3	+	4	+	1	+	2	+	3	+	4	+
(X)		X		X			(X)	X		X		(X)		X	
X		X			(X)	X		X			(X)	X		X	

In six, on the other hand, a 7-beat cross-rhythm has one *more* beat than the 6-beat measure. So if a pattern of 7's starts on 1, the second figure will start on 2, the next on 3, and so on in *ascending* order. You can see this sequence in the next chart, where we run 7's for four measures before cutting the pattern short and letting it repeat. Notice that this 7-beat cross-rhythm creates the short bell on the first row and the long bell on the second:

PATTERN 34-6

1	2	3	4	5	6	1	2	3	4	5	6
X		X		O	O		X		X		O
O	X		X		O	O		X		X	
	O	O		X		X		O	O		X
	X		O	O		X		X		O	O

Here's the third row of this pattern as a repeating pattern on its own:

PATTERN 34-7

1	2	3	4	5	6	1	2	3	4	5	6
	O	O		X		X		O	O		X

Now make up your own 7-beat cross-rhythms and play around with them. But when you play them in public, remember that because they obscure the underlying pulse you need to handle them with care. Always consider how a cross-rhythm will affect the musicians you're playing with and your audience. Don't abandon the dancers. Strive for the right balance between tension and release, between playing inside and outside the groove.

CHAPTER **12**
Polyrhythms
with uneven grids

3 over 2 eighth notes in four and six

In Lesson 16, when we introduced 3 over 2, we defined a polyrhythm as two patterns perceived at the same time that *a)* create or imply uneven pulses *or b)* have uneven grids. All the polyrhythms you've played so far have had uneven pulses. In this chapter, we finally get to polyrhythms created by patterns with **uneven grids**. Two grids are uneven when neither contains all the subdivisions of the other.

In the second measure of the next chart, we've superimposed eighth-note triplets – 3 notes played evenly in the same span of time as 2 eighth notes – over the eighth-note grid. The eighth-note triplet grid is uneven with the eighth-note grid because – although the two grids coincide on each numbered beat – neither grid contains all the subdivisions of the other:

PATTERN 35-1

1	+	2	+	3	+	4	+	1	+	2	+	3	+	4	+
X	O	X	O	X	O	X	O	x o o	x o o	x o o	x o o				

All you need to do to play an eighth-note triplet accurately is play the first note on a numbered beat and space the other two notes evenly across the distance to the next numbered beat. (It's possible to start a triplet on an offbeat, but it's a lot harder. For now, stick to numbered beats.)

Whenever we use the sign of a curved line over three notes in the space of two-eighth notes, it indicates that the notes under it form an eighth-note triplet. We superimpose the eighth-note triplets over the eighth-note grid to show the polyrhythmic relationship between the two. To feel this relationship, it really helps to play the patterns along with the timeline because the timeline helps define the underlying eighth-note grid.

You can *substitute a triplet* for any two eighth notes. That's what we do at the beginning of the second figure in the next pattern:

VARIATION TECHNIQUE

Substitute a triplet

PATTERN 35-2

1	+	2	+	3	+	4	+	1	+	2	+	3	+	4	+
		X	X	O	O	O	O		x͡	x	x	O	O	O	O

In the second measure of the next chart we *camouflage* the eighth-note triplets. **Camouflaging** is the use of voicing to disguise the underlying structure of a pattern. Here the three-note structure of the triplets in the second measure is camouflaged with voicing that changes every two notes:

VARIATION TECHNIQUE

Camouflage

PATTERN 35-3

1	+	2	+	3	+	4	+	1	+	2	+	3	+	4	+
x͡	x	x	o͡	o	o	x͡	x	x	o͡	o	o			x͡	o o

In the next chart, we've taken a pattern you played in lesson 32 and substituted triplets for the O's in the figures in the first row:

PATTERN 35-4

1	+	2	+	3	+	4	+	1	+	2	+	3	+	4	+
o͡ o o	o͡ o o	X		o͡ o o	o͡ o o	X		o͡ o o	o͡ o o						
X		X	X		X	X		O		O	O		O	O	

Be careful to maintain a clear distinction in your playing between two sixteenth notes followed by an eighth note and an eighth-note triplet. Focusing on the first note that marks the return to the eighth-note grid will help you do that. For example, in the first measure of the next pattern, after you play the two sixteenth notes you need to lock into the eighth-note grid on the AND of 2. But in the

second measure, when you play the triplet you won't lock into the eighth-note grid until 3:

PATTERN 35-5

1	+	2	+	3	+	4	+	1	+	2	+	3	+	4	+
		x x	X	O	O	O	O			x	x	x	O	O	O

VARIATION
TECHNIQUE

Swing

Funk and jazz players often **swing** notes in four from the eighth-note grid to the eighth-note triplet grid. To do that, just take any note that falls on an offbeat and play it as if it were the third note of an eighth-note triplet starting on the previous numbered beat. When you *swing* those notes, they come just a little later, closer to the following numbered beat — exactly how much later and closer is often affected by individual style and the tempo of the music. In the next chart, the straight eighth-note pattern in the first row is swung in the second row. Notice that when a note is omitted from a triplet, we indicate it with a dash:

PATTERN 35-6

1	+	2	+	3	+	4	+	1	+	2	+	3	+	4	+
O		O	O	X		O	O	O		O	O	X		O	O
O		ō	– ō	X		ō	– ō	O		ō	– ō	X		ō	– ō

Now switch to six. Because the odd-numbered beats are an alternative pulse in six and an easy pathway through the eighth-note grid, the easiest way to play an eighth-note triplet is to start it on an odd-numbered beat. Then all you need to do to play the triplet accurately is space the 3 notes evenly across the distance from one odd-numbered beat to the next. Starting on an even-numbered beat is harder.

In the next chart, there are triplets starting on each of the odd-numbered beats in the second measure. Make sure all the notes in the triplets are evenly spaced, and the X's in the second measure are as even as the X's in the first:

PATTERN 35-7

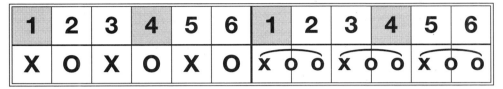

The triplets in the second measure of the next pattern start on 1 and 3. Make sure you play the X in the same spot in both measures:

PATTERN 35-8

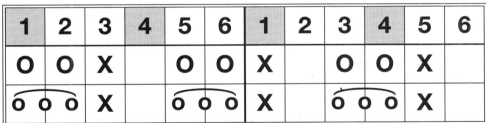

In the second row of the next pattern, we substitute triplets for the first two eighth notes in each three-note figure:

PATTERN 35-9

1	2	3	4	5	6	1	2	3	4	5	6			
O	O	X		O	O	X		O	O	X				
o	o	o	X		o	o	o	X		o	o	o	X	

We've only scratched the surface on the subject of eighth-note triplets, but we've given you enough to get you started. Once you get the feel for this grid and its polyrhythmic relationship to an underlying eighth-note grid, go ahead and try substituting eighth-note triplets for any two eighth notes in any pattern in four or six.

Subdividing the pulse in four into 3

When you divide a pulse in four into 3 subdivisions you create quarter-note triplets. In the second measure of the next chart, we superimpose quarter-note triplets over the eighth-note grid. A curved line spanning a distance of four eighth notes (equal to two quarter notes) indicates that the notes under it are a quarter-note triplet.

The easiest way to learn to play quarter-note triplets in four is to use the pulses as your reference points. Then all you have to do is space three notes evenly across the distance from one pulse to the next. Again, to feel the polyrhythmic relationship between the triplets and the underlying eighth-note grid, play along with the timeline:

PATTERN 36-1

1	+	2	+	3	+	4	+	1	+	2	+	3	+	4	+
X		X		O		O		x	x	x		o	o	o	

Now practice switching from eighth notes in the first measure to quarter-note triplets in the second:

PATTERN 36-2

1	+	2	+	3	+	4	+	1	+	2	+	3	+	4	+		
X	X	X	X	O	O	O	O	x		x		x	o		o		o

The next exercise combines the previous two patterns, so you go from quarter notes to quarter-note-triplets to eighth notes and back:

PATTERN 36-3

1	+	2	+	3	+	4	+	1	+	2	+	3	+	4	+	
X		X		O		O		x	x	x		o	o	o		
X	X	X	X	O	O	O	O	x		x		x		o	o	o

Now you're going to play quarter-note triplets through the whole cycle. Keep using the pulses – not the timeline – as your main reference, and focus on dividing each pulse evenly into 3. Let the timeline play at the edge of your awareness most of the time, but check in with it when it coincides with the pulse on its first and last notes. Once it's easy for you to play steady quarter-note triplets, you'll be able to tune in to the subtle polyrhythmic relationship between the triplets and the three middle notes of the timeline:

PATTERN 36-4

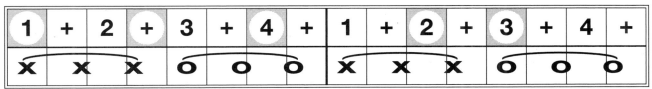

You can camouflage quarter-note triplets with voicing to create three groups of four notes:

PATTERN 36-5

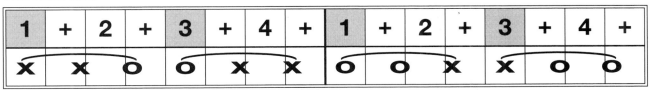

Now create space by leaving off the first note in each measure. Notice again that when a note is omitted from a triplet, we indicate it with a dash:

PATTERN 36-6

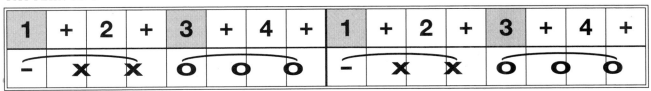

Now play the same pattern with O's on just 3 and 4. You'll be able to switch speeds more easily if you consciously feel the missing notes on 1:

PATTERN 36-7

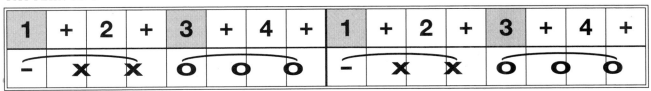

The next pattern uses both eighth-note and quarter-note triplets. It also illustrates the technique of *playing off marks*. **Marks** are notes in a pattern that remain constant while everything around them is varied. In this pattern, the marks are the notes on 4 and the AND of 4 in both measures. But even these marks are varied slightly in the last two rows when they are incorporated into the quarter-note triplets:

PATTERN 36-8

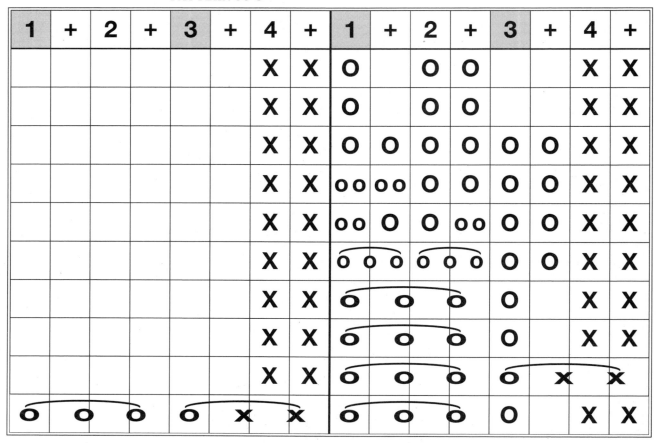

1	+	2	+	3	+	4	+	1	+	2	+	3	+	4	+		
						X	X	O		O	O			X	X		
						X	X	O		O	O			X	X		
						X	X	O	O	O	O	O	O	X	X		
						X	X	oo	oo	O	O	O	O	X	X		
						X	X	oo	O	O	oo	O	O	X	X		
						X	X	o o o		o o o		O	O	X	X		
						X	X	o		o		o		O	X	X	
						X	X	o		o		o		O	X	X	
						X	X	o		o		o		o	X	X	
o		o		o		o	X	X	o		o		o		O	X	X

You can feel how shifting to an uneven grid can add spice to a rhythm without disturbing the groove. That's because polyrhythms with uneven grids – unlike polyrhythms with uneven pulses and most cross-rhythms – don't obscure the underlying pulse. They simply divide the space *between* pulses differently.

lesson

Subdividing the pulse in six into 2 and 4

When you divide a 4-pulse in six into 2 subdivisions, each note is a dotted eighth note. A curved line spanning a distance of three eighth notes with two notes under it indicates that the notes are dotted eighth notes. Here's what they look like on our charts (you don't need to play the pattern yet):

PATTERN 37-1

1	2	3	4	5	6	1	2	3	4	5	6
x	x		x	x		x	x		x	x	

Notes on this dotted-eighth-note grid form the polyrhythm 2 over 3 with the eighth-note grid. The first of each pair of dotted eighth notes falls on the pulse and the second falls midway between pulses. Playing the note that falls on the pulse is no problem. But when you're feeling the eighth-note grid, finding the spot midway between pulses where the elusive upbeat in six falls can be tricky.

The easiest way to learn the location of the beat midway between pulses is to work off a sixteenth-note grid. That grid has a beat midway between each two pulses – the second sixteenth note under beats 2 and 5 in each measure:

PATTERN 37-2

1	2	3	4	5	6	1	2	3	4	5	6
x x	x⊗	x x	x x	x⊗	x x	x x	x⊗	x x	x x	x⊗	x x

By gradually creating space in this grid, you'll eventually get to the dotted-eighth-note grid. That's what you'll do in the following patterns. Play them without the timeline at first if you need to. But to create the polyrhythm of 2 over 3 – and to really bring the patterns to life – you need to play each pattern with the timeline.

Start whittling away at the continuous sixteenth notes by taking out the second sixteenth note on beats 1 and 3:

PATTERN 37-3

1	2	3	4	5	6	1	2	3	4	5	6
X	xx	X	X	xx	X	X	xx	X	X	xx	X

Try to hear the dotted-eighth-note grid by playing it with the alternate voice:

PATTERN 37-4

1	2	3	4	5	6	1	2	3	4	5	6
O	xo	X	O	xo	X	O	xo	X	O	xo	X

When you get comfortable with this pattern, start taking out the X's one by one. At the first sign of shakiness on the O midway between pulses, slide those X's back in to steady yourself:

PATTERN 37-5

1	2	3	4	5	6	1	2	3	4	5	6
O	xo	X	O	xo		O	xo	X	O	xo	

PATTERN 37-6

1	2	3	4	5	6	1	2	3	4	5	6
O	xo		O	xo		O	xo		O	xo	

PATTERN 37-7

1	2	3	4	5	6	1	2	3	4	5	6
O	xo		o͡	o		O	xo		o͡	o	

PATTERN 37-8

1	2	3	4	5	6	1	2	3	4	5	6
O	xo		o͡	o		o͡	o		o͡	o	

PATTERN 37-9

1	2	3	4	5	6	1	2	3	4	5	6
o͡	o		o͡	o		o͡	o		o͡	o	

When you're comfortable with the dotted-eighth-note grid, you're ready to switch between it and the eighth-note grid. In the next pattern, all the notes are on the eighth-note grid until the second half of the second measure. Then the dotted eighth notes make time slow down:

PATTERN 37-10

1	2	3	4	5	6	1	2	3	4	5	6
X		O	X			X		O	x͡		x

The next pattern consists of phrases played on the lead drum in the Ghanaian rhythm agbaja (ahg-bah-zha). Notice that the bottom row combines eighth notes, sixteenth notes, and dotted eighth notes:

PATTERN 37-11

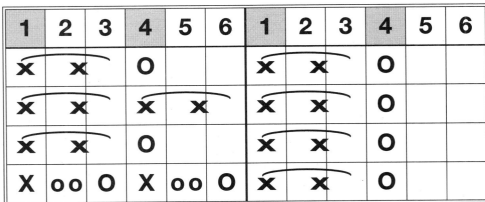

When you divide a 4-pulse in six into 4 subdivisions, each beat equals a dotted sixteenth note. A curved line spanning a distance of three eighth notes with four notes under it indicates the notes are dotted sixteenth notes:

PATTERN 37-12

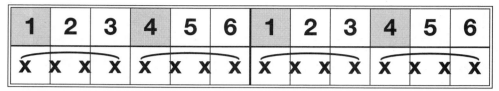

There's no way to micro-manage the 4 over 3 relationship of dotted sixteenth notes to eighth notes; everything goes by too fast. The only way to play dotted sixteenth notes in six is to use the 4-pulse as your reference and focus on dividing each pulse into 4. To feel the polyrhythm, you need to turn the timeline on, even if you play it at the slowest speed. Here are consecutive dotted sixteenth notes with alternating voicing:

PATTERN 37-13

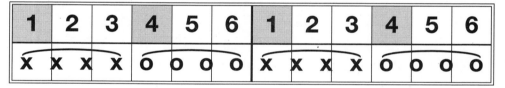

You won't often hear the pulse in six divided into 4 subdivisions because it creates such a dense polyrhythm with the eighth-note grid. But we did want to at least introduce it to you so you'll know enough to get started in case you want to explore it on your own.

lesson **38**

Bending a pattern between four and six

VARIATION
TECHNIQUE

Bend

Bending a pattern back and forth is like performing rhythm magic. By **bending** we mean moving a pattern between the eighth-note grid in four and the eighth-note grid in six while keeping the pulse constant.

To make this technique clear we've created a special chart. On the top it has a count row and an eighth-note grid in four. On the bottom it has a count row and an eighth-note grid in six. The grid in six is elongated so the pulses in four and six line up:

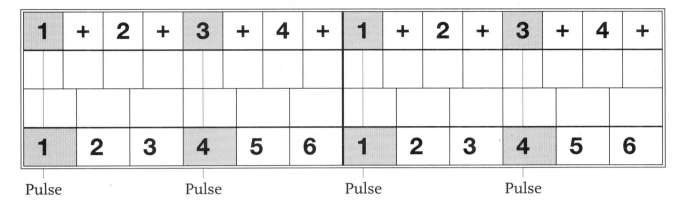

Pulse Pulse Pulse Pulse

Before you try bending any patterns, practice going back and forth between counting a cycle in four and counting a cycle in six while keeping a constant pulse in your feet.

Now you're ready to bend the set of parallel pairs consisting of the two beats before each pulse. Leave out the timeline for now and just concentrate on keeping the pulse steady as you alternate between playing the pairs in four and playing them in six:

PATTERN 38-1

1	+	2	+	3	+	4	+	1	+	2	+	3	+	4	+
		X	X			X	X			X	X			X	X

	X	X		X	X		X	X		X	X
X		X		X		X		X		X	
1	2	3	4	5	6	1	2	3	4	5	6

Notice that when you bend from four to six, the notes stretch out, and when you bend back from six to four, the notes get tighter. Movement in each direction carries a different emotional charge. Bending from four to six slows time down and heightens drama; bending from six back to four speeds time up and restores momentum.

If a timeline or other parts played on the eighth-note grid in four continue while you bend a pattern to six, the bent pattern will in effect be on the quarter-note triplet grid in four. This will create an uneven-grid polyrhythm and you and your listeners will feel that you're bending against some resistance. You can feel this effect by playing all the patterns in this lesson along with the timeline in four.

On the other hand, if all the musicians you're playing with bend *with* you to the eighth-note grid in six, there's no polyrhythm. You'll simply have switched from four to six. You can feel this effect by playing all the patterns in this lesson without the timeline. We recommend you try bending both ways.

The first step to mastering the technique of bending is knowing how to pick patterns that bend well. Some don't. For example, because there are 4 subdivisions to a pulse in four but only 3 to a pulse in six, if you fill the grid in four with consecutive eighth notes you'll have trouble bending the pattern. One out of every four notes will have nowhere to go on the grid in six. To avoid a game of musical chairs when you bend, choose patterns in four with no more than three notes to a pulse.

Here's an example of a pattern in four that's a good candidate for bending. It's the essence of the tumbao pattern you played back in lesson 3:

PATTERN 38-2

1	+	2	+	3	+	4	+	1	+	2	+	3	+	4	+
		X				O	O			X				O	O

Since the O's in each measure are the two beats before the pulse in four, when we bend this pattern they'll move to the two beats before the pulse in six (just as they did in the last pattern). But what about the lonely X on 2 in each measure? To decide where to move it we need to take a closer look at the mechanics of moving individual notes from the grid in four to the grid in six.

Notes on the pulses in four are easy; they move to the corresponding pulses in six. And notes on the beats before or after the pulse in four are easy too; they move to the corresponding beats before or after the pulse in six. But the upbeats in four – beats 2 and 4 – don't have corresponding beats on the eighth-note grid in six. So an individual note on an upbeat needs to go either to the beat before or after the pulse in six, depending on the pattern:

Deciding where to send an individual note from an upbeat in four requires musical judgment. Whenever possible, try out both possibilities to find which works best in a particular situation. Here are both possibilities for bending the tumbao pattern. You need to decide which fits best in the musical context you're playing in:

PATTERN 38-3

1	+	2	+	3	+	4	+	1	+	2	+	3	+	4	+
		X				O	O			X				O	O
	X				O	O			X				O	O	
1	2	3	4	5	6	1	2	3	4	5	6				

PATTERN 38-4

1	+	2	+	3	+	4	+	1	+	2	+	3	+	4	+
		X				O	O			X				O	O
			X		O	O				X		O	O		
1	2	3	4	5	6	1	2	3	4	5	6				

Here's another candidate for bending. It's the melody of the rumba guaguanco in abstract form:

PATTERN 38-5

1	+	2	+	3	+	4	+	1	+	2	+	3	+	4	+
						O	X		X				O		

Notice that the O's in this pattern fall on upbeats, so we have to decide where to put them when we bend. Moving them to beat 5 in six works well because it preserves the empty beat between the O in the first measure and the following X:

PATTERN 38-6

1	+	2	+	3	+	4	+	1	+	2	+	3	+	4	+
						O		X			X			O	
					O			X		X			O		
1		2		3	4		5		6		1	2		3	4

(six: 1 2 3 4 5 6 | 1 2 3 4 5 6)

The next pattern consists of three-note figures in four:

PATTERN 38-7

1	+	2	+	3	+	4	+	1	+	2	+	3	+	4	+
X		X	X		X	X	X		X	X			X		X

When you bend this pattern, the note on each pulse in four will go to the pulse in six and the note on the beat before each pulse in four will go to the beat before each pulse in six. The note on each upbeat in four will then have nowhere to go but to the beat after each pulse in six. So

in six this pattern will fill the grid, and bending will create the same effect as playing steady quarter-note triplets in four:

PATTERN 38-8

Four grid:

1	+	2	+	3	+	4	+	1	+	2	+	3	+	4	+
X		X	X	X		X	X	X		X	X	X		X	X

Six grid:

X	X	X	X	X	X	X	X	X	X	X	X
1	2	3	4	5	6	1	2	3	4	5	6

You can bend the son clave timeline in four to form the skeleton of the long bell in six if you move the two notes that fall on upbeats in four (4 in the first measure and 2 in the second) to the beat after the pulse in six. Turn off the timeline on the CD for this one:

PATTERN 38-9

Four grid:

1	+	2	+	3	+	4	+	1	+	2	+	3	+	4	+
X			X			X				X		X			

Six grid:

X		X		X			X		X		
1	2	3	4	5	6	1	2	3	4	5	6

Bending the rumba clave pattern in the same way produces the skeleton of the short bell pattern in six (also called the 6/8 clave). Keep the CD off for this one too:

PATTERN 38-10

Four grid:

1	+	2	+	3	+	4	+	1	+	2	+	3	+	4	+
X			X				X			X		X			

Six grid:

X		X			X		X		X		
1	2	3	4	5	6	1	2	3	4	5	6

Bending a pattern from four to six is a common technique in Afro-Cuban music. Once you get familiar with it, you can then begin to explore the possibilities of bending a pattern only part way, so that it's neither in four nor six but somewhere in between. But that subtlety takes us beyond what can be explained and taught, and into the realm of what can only be heard and felt.

CHAPTER **13**
Glossary

There is little consensus on the definitions of many of the most basic terms related to rhythm. Our definitions are intended to be practical and functional, not to cover every conceivable mathematical possibility. For the sake of simplicity, some terms – like "polyrhythm" and "compound cycle" – are defined in reference to two patterns, but they can also apply to more than two patterns. When terms are readily understood by any musician – like "eighth note" and "measure" – we've taken advantage of that and avoided the work of defining them. Following each definition is the number of the page on which the term is introduced.

accent: a feature of a sound that makes it stand out from its surroundings (58)

backbeats: every second pulse (72)

beat: an individual subdivision (12)

bending: moving a pattern between the eighth-note grid in four and the corresponding beats on the eighth-note grid in six while keeping the pulse constant (185)

camouflaging: the use of voicing to disguise the underlying structure of a pattern (175)

clave (klah-vay): a timeline in Afro-Cuban music, usually played on two cylindrical pieces of wood called claves (14)

composite pattern: the pattern created by playing all the notes of two patterns with the same sound without doubling the notes on beats where the two patterns coincide (95)

compound cycle: the number of beats it takes for the combination of two patterns to repeat (154)

compressing: taking out space between or within repeating figures so more of them fit within a cycle (128)

counter-rhythm: the pattern in a polyrhythm perceived as being played over the pattern that creates or implies the underlying pulse or grid (94)

cross-rhythm: a repeating figure played for longer than a cycle of the timeline that has an uneven cycle in relation to the cycle of the timeline (or whatever part defines the underlying cycle of a rhythm) (154)

cut-time: the time signature in which a pulse falls on every half note and there are two half notes to a measure (13)

cycle: the number of beats from the start of one repetition of a repeating pattern to the start of the next; when we use the term without further explanation we're referring to the cycle of the timeline (15)

dynamic accent: the accent created when a sound stands out because of how loud or soft it's played (58)

expanding: adding space between or within repeating figures so fewer of them fit within a cycle (150)

flam: an effect produced by playing two notes almost simultaneously, one note on the beat and one note just before it (145)

figure: a short rhythmic pattern (36)

four: our shorthand description of the time signature of a pattern that can logically be represented on a chart with four pulses divided into four subdivisions each (13)

4-pulse: the pulse in four or six with 4 pulses to a cycle of the timeline (92)

ghost notes: barely-audible, timekeeping taps (65)

grid: any set of equal subdivisions (12)

half-time: a 2-pulse feel in four or six (98)

marks: notes in a pattern that remain constant while everything around them is varied (180)

metric modulation: switching from one pulse to another uneven pulse while keeping the subdivisions the same length (135)

offbeats: all beats between pulses (except upbeats) (64)

onbeats: all beats that aren't offbeats (65)

ONE: the first beat in a cycle (32)

pair: two notes on consecutive beats (36)

parallel figures: two or more figures that have the same structure and the same relationship to the pulse (36)

polyrhythm: the rhythm created when two patterns are perceived at the same time that *a)* create or imply uneven pulses *or b)* have uneven grids (93)

prefix: a note or notes attached before another note or figure (80)

pulse: the steady, metronomic, underlying rhythm people feel in their bodies when music is played (12)

pulses: individual, regularly-spaced, kinesthetic events making up a pulse (12)

reverse image: a pattern derived by playing notes on the empty beats of another pattern (121)

shifting: keeping a pattern the same while starting it on a different beat (54)

six: our shorthand description of the time signature of a pattern that can logically be represented on a chart divided into two measures of six beats each (14)

6/8 time: the time signature in which there are six eighth notes to a measure (14)

6-pulse: the pulse in six with 6 pulses to a cycle of the timeline (92)

subdivisions: the smaller units into which the time span between pulses is divided (12)

suffix: a note or notes attached after another note or figure (81)

swing: to take a note on an offbeat in four and play it as if it were the third note of an eighth-note triplet starting on the previous numbered beat (176)

3-pulse: the pulse in six with 3 pulses to a cycle of the timeline (134)

timeline: an audible, asymmetrical, repeating rhythmic pattern around which a rhythm is organized that is used as a reference rhythm by the players in a group (14)

triple-weave practicing: playing a pattern while tapping a pulse in your feet and listening to a timeline (28)

2-pulse: the pulse in four or six with 2 pulses to a cycle of the timeline (also called a "half-time" feel) (98)

uneven cycles: two cycles are uneven when you can't evenly divide the number of beats in the longer cycle by the number in the shorter (154)

uneven grids: two grids are uneven when neither contains all the subdivisions of the other (174)

uneven pulses: two pulses are uneven if neither contains all the notes of the other (when the two pulses are started together) (94)

upbeat: a beat falling midway between two pulses (61)

voicing: the sound of a note (40)

CHAPTER **14**
Rhythm walking

If you really want to get rhythms into your bones, there's nothing like rhythm walking. Rhythm walking is a fun method for practicing patterns with just your body. There are two ways to do it. You can simply walk a pulse while you clap or vocalize a pattern. Or you can do triple-weave rhythm walking by walking a pulse, clapping a timeline, and vocalizing a pattern all at the same time.

Rhythm walking is a form of rhythmic cross-training you can do anywhere: at a park, on a beach, down a city street. It loosens up those muscles and joints that get stiff and sore when you overpractice on your instrument. And it's a great way to work on your rhythmic vocabulary while you get some exercise and fresh air.

To show you how it's done, we explain what to do with your feet first, and then build from there to your hands and voice.

Feet

In rhythm walking, the pulse is always in your feet. So to get the pulse going, all you have to do is start walking. Once you're moving you shouldn't have to think about your feet at all. But you do need to decide at the start which pulse you're stepping because that will affect any pattern you add in your hands or voice.

When you rhythm walk in four, one way to think of your steps is as pulses falling on 1 and 3. This will work fine on simple patterns and patterns you already know well. But when you're trying to coordinate feet, hands, and voice on a new or difficult pattern, this pulse may make it move too fast. To slow a pattern down *without changing your walking speed*, think of your steps as pulses falling on every numbered beat:

1	+	2	+	3	+	4	+	1	+	2	+	3	+	4	+
👣		👣		👣		👣		👣		👣		👣		👣	

When you rhythm walk in six, you can think of your steps as pulses falling on 1 and 4. This 4-pulse is the right speed for most patterns. But if you need to you can slow a pattern down in six by thinking of your steps as a 6-pulse falling on the odd-numbered beats:

1	2	3	4	5	6	1	2	3	4	5	6
👣		👣		👣		👣		👣		👣	

If you want to speed up a pattern in six or just want a change of perspective, think of your steps as a 3-pulse:

1	2	3	4	5	6	1	2	3	4	5	6
👣				👣				👣			

Hands

While you walk the pulse, you can add a second pattern in your hands. To play a timeline or a pattern with only one voice, you can simply clap it. Or you can hit any two objects together: claves, coins, keys, sticks, stones – whatever's handy.

But having to bring your hands together while you walk prevents you from swinging your arms freely. If you want to walk normally, you need to be able to make a sound with just one hand.

One simple solution is to tape one quarter to your thumb and another one to your middle finger. Then you can create a click by bringing them together. If you use buttons instead of quarters, you can strap them to your fingers with little strips of elastic. If you want to play a pattern with two voices, just use metal in one hand and wood or plastic in the other.

You can make a richer sound with one hand using a frikyiwa (free-kee-wah), a small, egg-shaped bell used in Ghana and other African countries. Traditionally the bell is slipped over the middle finger and struck with a metal ring slipped over the thumb. But to muffle the bell and

avoid disturbing others, you can cup it in the palm of your hand and tap it lightly with the metal ring on your middle finger:

To keep one hand from getting tired – and to keep yourself from becoming rhythmically unbalanced – it's best to alternate hands. You can also avoid fatigue by choosing simple timelines or patterns without too many notes. The timeline in four we use throughout this book works well, because it has only five notes. But the timeline in six has seven notes in the space of 12 beats, so you may want to simplify it to the following pattern:

1	2	3	4	5	6	1	2	3	4	5	6
X		X			X		X		X		

If you're looking for other timeline options, you'll find them in lessons 14 and 21.

Voice

While you walk the pulse, instead of adding a second pattern in your hands, you can add it in your voice. Or if the pulse is in your feet and a timeline is in your hands, you can use your voice to add a third pattern (or put the timeline in your voice and the third pattern in your hands).

To vocalize a pattern with just one voice, choose any sound you like. If a pattern has two voices, choose contrasting sounds for X's and O's. Use any syllables that feel natural to you. (We like "bop" for X's and "doo" for O's.) Then try using two distinct pitches for the two sounds, with the X higher than the O. If you feel like it, sing melodies. Before you know it, you'll be making up songs.

So get out of the basement. Put on your walking shoes and give your roommates a break. Go for a rhythm walk. The change of scenery will do you good.

Rhythm walking when you can't walk

Sometimes it's just not possible to walk, but that doesn't have to slow you down. Let's say you're stuck in line at the grocery store or the post office. You can always step a pulse while standing in place, clap a timeline lightly in your hands, and mutter a pattern under your breath. Of course you have to get used to people staring at you. Just smile and try to look harmless.

If you're *sitting* in a waiting room or riding on a train, you can still rhythm walk – just tap a pulse in your feet like you've been doing all along. Rhythm walking is the perfect activity for people who can't sit still and don't like to kill time.

You can even rhythm walk lying flat on your back by twitching your toes. Remember: No matter where you are, or how restrictive your environment may seem, there's always room to groove.

Blank charts

1	+	2	+	3	+	4	+	1	+	2	+	3	+	4	+

1	+	2	+	3	+	4	+	1	+	2	+	3	+	4	+

1	+	2	+	3	+	4	+	1	+	2	+	3	+	4	+

1	+	2	+	3	+	4	+	1	+	2	+	3	+	4	+

1	2	3	4	5	6	1	2	3	4	5	6

1	2	3	4	5	6	1	2	3	4	5	6

1	2	3	4	5	6	1	2	3	4	5	6

1	2	3	4	5	6	1	2	3	4	5	6

A RHYTHMIC VOCABULARY – FEEL FREE TO PHOTOCOPY THIS PAGE

Sources: books, videos, CDs, and audiotapes

Books on African or Afro-Cuban rhythms (and accompanying CDs or cassettes)

African Rhythm and African Sensibility by John Chernoff, The University of Chicago Press, 1979.

Afro-Cuban Grooves for Bass and Drums: Funkifying the Clave by Lincoln Goines and Robby Ameen, Manhattan Music, 1990. Includes two CDs.

Afro-Cuban Rhythms for Drumset by Frank Malabe and Bob Weiner, Manhattan Music, 1990. CD also available.

Conga Drumming: A Beginner's Guide to Playing with Time by Alan Dworsky and Betsy Sansby, Dancing Hands Music, 1994. Includes CD.

Drum Gahu: The Rhythms of West African Drumming by David Locke, White Cliffs Media, 1987. Cassette also available.

The Essence of Afro-Cuban Percussion by Ed Uribe, CPP Media Group, 1996. Includes two CDs.

Afro-Cuban Grooves for Bass and Drums by Lincoln Goines and Robby Ameen, Manhattan Music, 1990. Includes two CDs.

Kpegisu: A War Drum of the Ewe by David Locke, featuring Godwin Agbeli, White Cliffs Media, 1992. Cassette also available.

Practical Applications Using Afro-Caribbean Rhythms (Parts 1, 2, and 3) by Chuck Silverman, CPP/Belwin, 1991.

Rhythms and Techniques for Latin Timbales by Victor Rendon.

Salsa Guidebook For Piano and Ensemble by Rebeca Mauleon, Sher Music, 1993.

West African Rhythms for Drumset by Royal Hartigan with Abraham Adzenyah and Freeman Donkor, Manhattan Music, 1995. Includes CD.

Videos on African and Afro-Cuban drumming (and accompanying booklets)

Advanced Conga with Rolando Soto, MVP.

Conga Drumming: A Beginner's Video Guide with Jorge Bermudez, Dancing Hands Music.

Latin Soloing for the Drumset with Phil Maturano, Hal Leonard.

Mastering the Art of Afro-Cuban Drumming with Ignacio Berroa, Warner Bros.

Mozambique with Kim Atkinson, PulseWave Percussion.

The Rhythms of Guinea, West Africa with Karamba Diabate, 3rd Ear Productions.

Show Me the Rhythms for Bongos with Kalani, Kalani Music Video

Show Me the Rhythms for Jembe with Kalani, Kalani Music Video

CDs of traditional African and Afro-Cuban drumming

Obo Addy (Earthbeat) Okropong – Traditional Music of Ghana
Clave y Guaguanco (Xenophile): Songs and Dances
Adam Drame (Playasound): Mandingo Drums Volumes 1 and 2
Ensemble National de la Republique de Guinee (Musique du Monde):
 Les Ballets Africains
Famoudou Konate (Buda Records): Malinke Rhythms and Songs
Farafina (RealWorld): Faso Denou and Bolomakote
Fatala (RealWorld): Gongoma Times
Mamady Keita (Fonti Musicali): Mogobalu, Wassolon, Afo, Hamanah, and
 Nankama
Les Percussions de Guinee (Buda Records): Volumes 1 and 2
Los Munequitos De Matanzas (Qbadisc): Folklore Matancero, Congo
 Yambumba, and Rumba Caliente
Doudou Ndiaye Rose (Virgin Records): Djabote
Totico y sus Rumberos (Montuno Records): Totico y sus Rumberos
Yoruba Street Percussion (Original Music)

Miscellaneous other sources

Bayaka – The Extraordinary Music of the Babenzele Pygmies by Louis Sarno,
 Ellipsis Arts, 1995 (book and CD).
The Big Bang, Ellipsis Arts, 1994 (boxed set of three CDs of drumming from
 around the world with accompanying booklet).
Djembefola, Interama, 1991 (documentary video about Mamady Keita).
Drumming at the Edge of Magic – A Journey into the Spirit of Percussion by
 Mickey Hart, HarperCollins, 1990 (book).
Drum Solos Volumes 1, 2, and 3, Latin Percussion Ventures, 1978 (audiotapes
 on soloing on congas, bongos, and timbales).
Ta Ke Ti Na – The Forgotten Power of Rhythm by Reinhard Flatischler,
 LifeRhythm, 1992 (book with supplemental CD or cassette available).

Also available from Dancing Hands Music

$24.95

Conga Drumming
A Beginner's Guide to Playing with Time

BY ALAN DWORSKY AND BETSY SANSBY

This 160-page book with CD is a complete, step-by-step course on conga drumming. It teaches families of drum parts for several authentic Afro-Caribbean rhythms, including rumba, bomba, calypso, conga, and bembe. We use a simple charting system and the same friendly teaching style as A RHYTHMIC VOCABULARY. Life-like illustrations show you the proper technique for each stroke. And the CD that's included contains a sample recording of each of the 175 drum parts taught in the book as well as examples of how the parts sound together.

"Fantastic!" – RHYTHM MAGAZINE

"There is no other source for this kind of information that is as simply and sensibly explained, and contains such a wealth of rhythms. CONGA DRUMMING welcomes rather than intimidates beginners. Dig into this book and in a very short time you will be playing well. Bravo and muchas gracias Alan and Betsy!" – DRUM MAGAZINE

"The best book of its kind." – ARTHUR HULL

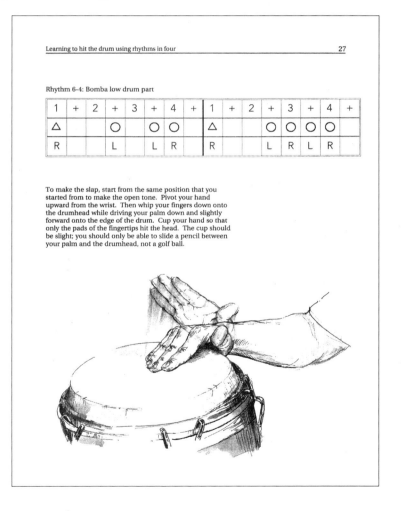

Learning to hit the drum using rhythms in four 27

Rhythm 6-4: Bomba low drum part

1	+	2	+	3	+	4	+	1	+	2	+	3	+	4	+
△			O		O	O		△			O	O	O	O	
R			L		L	R		R			L	R	L	R	

To make the slap, start from the same position that you started from to make the open tone. Pivot your hand upward from the wrist. Then whip your fingers down onto the drumhead while driving your palm down and slightly forward onto the edge of the drum. Cup your hand so that only the pads of the fingertips hit the head. The cup should be slight; you should only be able to slide a pencil between your palm and the drumhead, not a golf ball.

$29.95

Conga Drumming
A Beginner's Video Guide

This video gives you a chance to see how all the basic patterns from the CONGA DRUMMING book are supposed to be played. And it's a great way to learn proper playing technique, because we teach each stroke using multiple camera angles and slow-motion photography. The video features Jorge Bermudez and special guest Raul Rekow of Santana, with electrifying performances by Cuban dancer Rosie Lopez Moré, from the legendary Tropicana nightclub in Havana.

"A <u>must-see</u> for all beginners."
– MICKEY HART

"Slammin! The best video for learning to play congas."
– CHALO EDUARDO, PERCUSSIONIST WITH SERGIO MENDES

"Few videos capture the spirit of fun as well as CONGA DRUMMING. All the basics are covered and the educational information is interspersed with burning performances by the ensemble. When Rosie Lopez Moré is on screen the video is ablaze with energy."
– DRUM MAGAZINE

Find other drummers in your area by joining the Conga Connection FREE at dancinghands.com!

We've added the CONGA CONNECTION to our website as a free service to make it easier for drummers to find others who want to study, teach, jam, perform, and buy or sell equipment.